IMAGES
of Rail

JAMAICA STATION

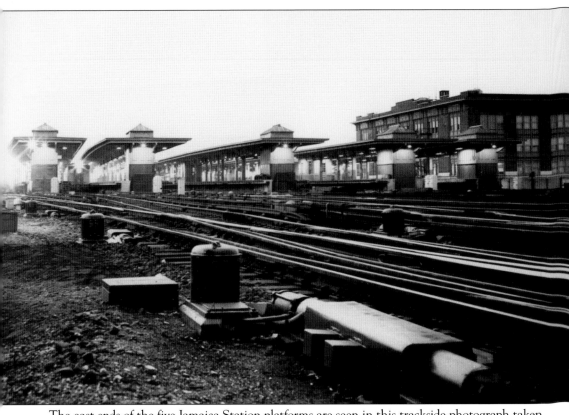

The east ends of the five Jamaica Station platforms are seen in this trackside photograph taken in the 1970s. The station building is in the background at right. (Courtesy of Gene Collora.)

IMAGES
of Rail

JAMAICA STATION

David D. Morrison

ARCADIA
PUBLISHING

Published by Arcadia Publishing
Charleston, South Carolina

Printed in the United States of America

Library of Congress Control Number: 2011926558

For all general information, please contact Arcadia Publishing:
Telephone 843-853-2070
Fax 843-853-0044
E-mail sales@arcadiapublishing.com
For customer service and orders:
Toll-Free 1-888-313-2665

Visit us on the Internet at www.arcadiapublishing.com

This book is dedicated to two men who had a great love for the history of the Long Island Rail Road. This photograph, taken at the Jamaica Station 75th Anniversary ceremony on March 9, 1988, shows John Hehman (left) standing with Richard "Old Man" Kelly. Both are deceased but fondly remembered. (Author's collection.)

CONTENTS

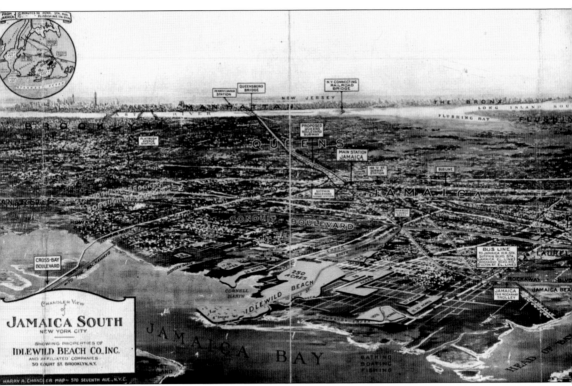

This 1929 map shows Jamaica Station, which appears slightly to the right of center, in relationship to the surrounding area. The view is looking west, with Manhattan Island at the top. The "N.Y. Connecting Railroad Bridge" identified at upper right is better known as Hellgate Bridge and today carries Amtrak trains toward Boston. "Idlewild Beach," located near the bottom-center of the map, is now the site of John F. Kennedy (JFK) International Airport. (Courtesy of Carl Ballenas.)

FOREWORD

Long Island, located just east of Manhattan, stretches more than 100 miles into the Atlantic Ocean. Today, it comprises two heavily populated boroughs of New York City—Brooklyn and Queens—and, farther out, the highly suburban but occasionally still-rural counties of Nassau and Suffolk. Miles of intricate coastline afford recreation, from enjoying sandy beaches to fishing and boating.

Two centuries ago, the picture was very different. In the 1830s, the Long Island Rail Road (LIRR), seeking a combined boat and rail route from Manhattan to Boston, began laying tracks through the mostly uninhabited middle of the island. One of the few farming villages along this east-west route was Jamaica. British settlers in the 17th century had derived its name from the "Yamecah," or "Jameco," Indians (a subtribe of the Canarsie, a Lenape people) who lived on the shore of a nearby bay. Trails worn by Indians traveling on foot, from near and far, converged at the inland site.

The LIRR rejoiced in 1844 when it reached the northeastern tip of the island, where passengers boarded ferries, crossed the Long Island Sound to Connecticut, and went on to Boston by rail. The jubilation was short-lived. Soon, financial scheming by steamboat baron Cornelius Vanderbilt, in addition to impending competition from a faster, more convenient all-rail route, would force the LIRR to reinvent itself. Within three years, the enterprise was abandoned. The LIRR's struggle for survival involved increasing income from local traffic. It constructed branchlines and bought up small railroads located along the north and south shores of the island, where numerous old whaling and fishing villages existed. By the 1870s, the LIRR had created a unified, but not particularly profitable, system of passenger and freight lines. It was well positioned, however, for monumental changes coming around the bend from Manhattan a few decades later.

The Pennsylvania Railroad became the majority stockholder of the LIRR in 1900. A year later, the Pennsy, as it was nicknamed, announced plans to construct tunnels under the Hudson River between New Jersey and Manhattan and under the East River between Manhattan and Long Island. The advent of electrified trains had eliminated the choking, vision-obscuring hazards that steam locomotives created inside tunnels, and long, under-river access was now possible. With the availability of this ferry-free connection to Manhattan, the LIRR decided to capitalize on the building boom expected to sweep over the island. To do so, the railroad rapidly electrified not only its lines coming out of New York's Pennsylvania Station but also several suburban ones. Adding to this expensive investment, the LIRR developed a completely new yard facility, switching and signaling plant, and station-headquarters building at the proverbial bottleneck of the railroad—Jamaica.

The LIRR expansion paid off. Today, because of its proximity to major population centers, Jamaica Station still serves as the central transfer point for people changing trains on the LIRR. Passengers can also transfer to three subway lines and a dozen local bus routes; and, in a major 2006 expansion, Jamaica became the connection for the new AirTrain JFK to John F. Kennedy International Airport. With more than 200,000 daily passengers, Jamaica Station continues to make history. David Morrison now takes us on a visual trip through major parts of that history to better understand and enjoy the growth and behind-the-scenes activity of Jamaica Station, heartbeat of the busiest commuter railroad in North America.

—Janet Greenstein Potter

ACKNOWLEDGMENTS

First and foremost, I would like to thank two fellow Long Island Rail Road retirees and historians—Arthur Huneke and Carol Mills. Arthur is a renowned photographer and railroad historian. He has an extensive collection of railroad archival material, and he is always willing to share his knowledge and collection with others who are researching railroads. His Jamaica Station construction-era photographs and information made Chapter Three possible. Carol has an in-depth knowledge of railroad history, and she is a world-class genealogist. She helped me fine-tune the text, and she was instrumental in tracking down some of the descendants of persons mentioned in Chapter Seven.

Erin Vosgien and Lisa Vear of Arcadia Publishing and Janet Greenstein Potter, author of *Great American Railroad Stations*, provided valuable input and guidance. Dave Keller provided beneficial information and suggestions, as well as some great interior views of the Jamaica Station waiting room prior to the 1972 renovations. Likewise, credit goes to Carl Ballenas for sharing his knowledge of local Jamaica community history, as well as maps and photographs.

The following persons contributed information and/or images: Michael Boland, James Brady, Wally Broege, Hays Browning, Michael Charles, Gene Collora, James Dermody, Pati deWardener, Carl Dimino, Bill Farnsworth, Richard Felter, Richard Glueck, Michael Hill, Arthur Lubitz, Lou Mallard, Robert Myers, Kirsten Nyitray, Claire Persico, Hugh Savage, John Specce, Jerry Strangarity, Robert Sturm, Heather Hill Worthington, Ron Ziel, and Ron Zinn.

Photographs credited to Vincent Alvino (deceased) were provided through the courtesy of his longtime friend James Mardiguian.

Finally, and probably most importantly, appreciation goes to my wife, Diane, who had the patience to see this project through to completion.

Unless noted otherwise, all images are from the author's collection.

INTRODUCTION

The early 20th century was a time of phenomenal growth and wealth for American railroads. In the first several decades of the 1900s, railroads were the sole means of overland transportation other than horses. The Wright brothers made their first flight on December 17, 1903, but it would be years before passenger air traffic came into existence. By 1900, mass production of automobiles had begun, but it would be a long time before cars were reliable enough to be able to travel great distances, and even after they could, the dirt and cobblestone roads made long-distance driving impractical and uncomfortable.

One hundred years ago, people moved all over the country by rail, and the railroad carriers were making enormous fortunes. Some of that wealth went into building lavish train stations to cater to the needs of the traveling public. Many examples can be seen in the developments in the New York City metropolitan area. The Delaware Lackawanna & Western Railroad finished its Hoboken Terminal in 1907. That same year, the Long Island Rail Road (LIRR) opened Flatbush Avenue Terminal. The Pennsylvania Railroad completed the late, great Pennsylvania Station in 1910, and the New York Central Railroad inaugurated Grand Central Terminal on February 2, 1913.

Shortly after all of this activity, the LIRR opened a new train station and headquarters in Jamaica. Although the new Jamaica Station wasn't on as grand a scale as some of the aforementioned stations, it was a major accomplishment for a railroad of its size. The LIRR ran principally on Long Island: from midtown Manhattan (Penn Station), under the East River through tunnels, through the borough of Queens, and out to the east end of Long Island, a distance of nearly 100 miles.

The importance of Jamaica Station should not be underestimated since it is the hub of the LIRR. All branches of the railroad, with the exception of the Port Washington Branch, converge at Jamaica. It is here that many passengers traveling from points east have to change trains to continue their trips to one of the three west end terminals: Long Island City, Flatbush Avenue Terminal (in Brooklyn), or Manhattan's Penn Station. Anyone who has ridden on the LIRR has heard the announcement to "change at Jamaica."

Jamaica Station is also the nerve center of the LIRR. It is here that the executive offices of the railroad are located. The train movement director's office is on the third floor, and it is from this location that the movement is governed for all trains on the entire railroad. The power director's office is also on the third floor. It is from here that the electrical distribution system is controlled for all of the miles of third-rail trackage.

Arcadia has already published three Images of Rail books on the Long Island Rail Road, which treat the railroad as a whole and are listed in the bibliography section. The purpose of this work is to concentrate on Jamaica, the heart of the system, where people and machines work together to allow the smooth movement of trains throughout a complex trackage network. This book will tell the story of the Jamaica Station building, its station platforms, signal towers, and interlocking tracks, as well as some outlying depots and many of the people who have helped make Jamaica Station work through the years.

In addition to the immediate Jamaica Station area, the scope of this book will include Dunton Shop and Dunton Tower, which are located in the southwest section of the Jamaica railroad area. The Morris Park Shops will not be covered, as it is a project unto itself. Some stations east of Jamaica have been included in this study insofar as they have relevance in telling the story of Jamaica Station.

Care has been taken to choose high-quality images, many of which have never before been published. The author's collection of Interstate Commerce Commission valuation photographs from 1919 was a great source of images. The author also has a large collection of original negatives of photographs taken by LIRR Claims Department photographer Fred J. Weber in the 1940s. James Mardiguian provided numerous photographs taken by Vincent Alvino in the 1960s and 1970s. Most impressive are the photographs from the collection of Arthur Huneke, which show the construction of the Jamaica Station complex.

The book is divided into eight chapters. Chapter One takes a look at the beginning decades of the railroad through Jamaica and the stations that served the area prior to the opening of the current Jamaica Station building.

Chapter Two covers the streets and grade crossings in the village of Jamaica at and near the original railroad station area. The elimination of these grade crossings was a key consideration in the design of the Jamaica Station improvements of 1913 and 1930.

Chapter Three contains unique views of construction scenes from the collection of a leading LIRR historian.

Chapter Four examines the five-story station/office building and its five passenger platforms. The design and layout of the stairways and pedestrian overpasses were designed to facilitate the expeditious flow of passengers changing trains.

Chapter Five will focus on the signal towers and the interlocking track system with its many switches, crossovers, and flyover tracks. This signal-and-switch system worked so well that no major changes were made during its 97 years of operation until modernization to a computerized system took effect in 2010.

Chapter Six provides a look at the different types of locomotives and passenger cars that have operated through the station over the years. From steam and electric locomotives to diesels and from diesel-hauled coaches to electric multiple-unit cars, the wide range of equipment that operated through Jamaica Station will be seen in photographs.

Chapter Seven celebrates a representative sampling of employees who have worked at or operated trains through Jamaica Station. Engineers, conductors, ushers, ticket clerks, managers and mini-maids were all a part of the workforce that made Jamaica Station function.

Chapter Eight highlights some artwork and memorabilia inspired by Jamaica Station. Included in this chapter are images from the 75th anniversary of Jamaica Station celebrated by the LIRR on March 9, 1988.

A 1929 Jamaica map from the collection of Carl Ballenas is provided on page 7. LIRR system maps may be found in the three previously published Images of Rail books pertaining to the LIRR.

It is hoped that this book will enhance the reader's knowledge of the Long Island Rail Road's main station and give a better understanding of the phrase "change at Jamaica."

One

EARLY RAILROAD
YEARS IN JAMAICA

As early as 1776, Jamaica served as a trading post for farmers and manufacturers. Established on an old Indian trail and later incorporated in 1814, it was the first village on Long Island. Transportation was via horse-drawn carriage or stagecoach. Produce was hauled in wagons. With the arrival of the railroad in 1836, the area underwent a major transformation, and Jamaica became a major population center in Nassau County. Jamaica would subsequently become part of New York City and, finally, Queens County.

In 1830, the first steam locomotive operated in the United States. A short time afterwards, in 1832, the Brooklyn & Jamaica Railroad (B&JRR) was formed to run from the Brooklyn waterfront to the village of Jamaica. The Long Island Rail Road was chartered in 1834 to provide a route from the Brooklyn waterfront through Jamaica and the center of Long Island to Greenport. After taking over the B&JRR, the LIRR ran its first through train in 1836. Almost immediately, the railroad extended eastward, reaching Hicksville in 1837.

By the mid-1800s, the LIRR was the primary means of bringing produce from the farms of Long Island into New York City and for bringing city merchandise out to Jamaica and Long Island. Virtually everything moved through Jamaica by rail.

This chapter contains images of the earliest years of the LIRR and of the years when its depot was located in the heart of the village of Jamaica.

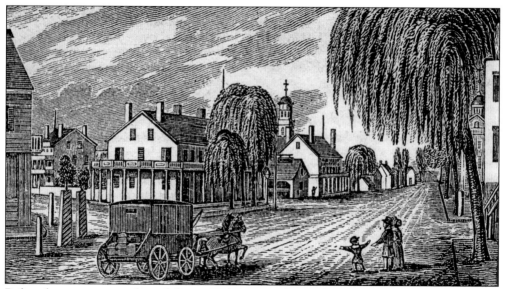

Before there were trains through Jamaica, there were dirt roads and horses, as seen in this early engraving of a stagecoach traveling along Jamaica Avenue. The building that appears just behind the stagecoach is Pettit's Hotel, where George Washington reportedly stayed. (Courtesy of Carl Ballenas.)

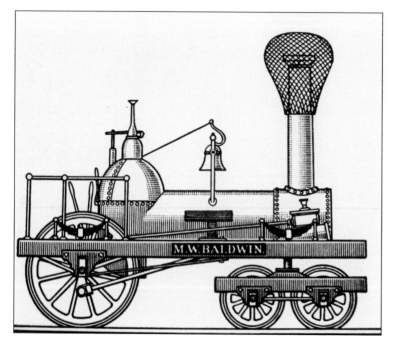

The first locomotive to appear in Jamaica was the *Ariel*, built by Matthias W. Baldwin in 1836. Baldwin started building steam locomotives after visiting Camden, New Jersey, in 1831, where he inspected the *John Bull*, which operated on the Camden & Amboy Railroad. Fortunately, this drawing of the *Ariel* has survived.

The first LIRR president, Knowles Taylor, was appointed on June 17, 1835. This is a photograph of a 1910 painting. The painting, which was missing for years, was found during a 1964 cleaning of the LIRR area of Penn Station in preparation for the demolition of that structure. Today, sadly, the whereabouts of the painting are again unknown.

The LIRR reached the village of Greenport, on the eastern end of Long Island's north fork, in 1844. That year, a tunnel opened below Brooklyn's Cobble Hill that allowed steam locomotives to power trains directly from the waterfront through Jamaica and east to Greenport. The tunnel was sealed in 1861 but was rediscovered by Robert Diamond in 1972. This early artwork survived over the years.

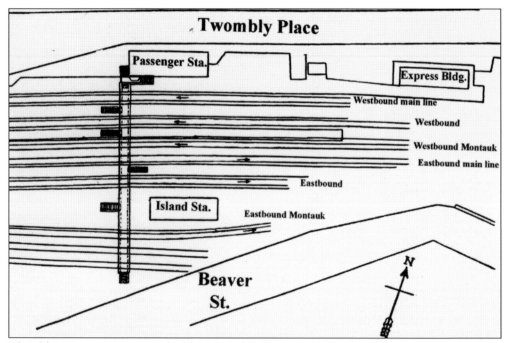

The old LIRR Jamaica Station building and platforms can be seen in relation to the local streets in this diagram. Twombly Place can be seen in the postcard image at the top of page 28. Fulton Street (later called Jamaica Avenue) would be one block north of Twombly Street (out of view at the top of this diagram).

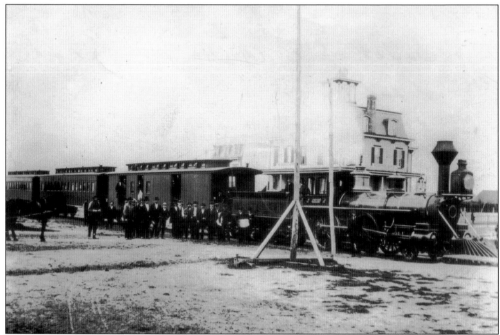

Although there is some dispute among railroad historians as to the location of this photograph, the handwriting on the reverse side of this sepia print reads, "Jamaica RR Station, year 1869, South Side RR train at the depot." There is a baggage car behind the locomotive tender.

Locomotive No. 48 sits at the New York Boulevard crossing in Jamaica around 1885. The uniformed man on the right may be the train conductor. In 1982, New York Boulevard was renamed Guy R. Brewer Boulevard by Mayor Edward Koch in honor of the late New York State assemblyman. (Courtesy of Ron Ziel.)

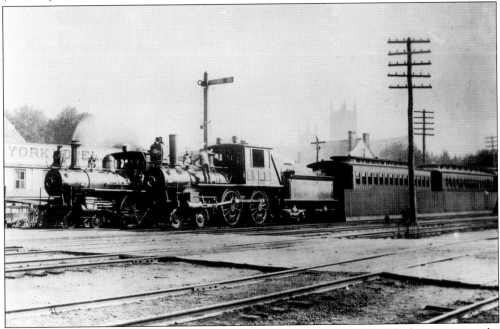

Two westbound trains await departure at the old Jamaica Station in 1886. The locomotive in the foreground is No. 86, built by the Rogers Locomotive Works in 1883. The steeples of the Dutch Reformed Church can be seen in the background.

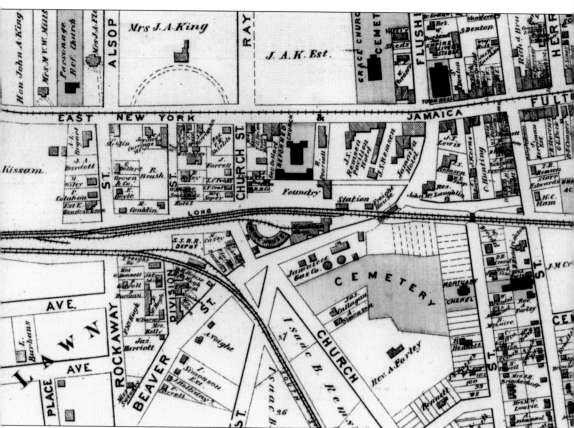

This 1873 Beers Atlas shows the old Jamaica Station. The former South Side Rail Road depot was near the Beaver Street crossing. The LIRR station was on the north side of the main line, opposite the cemetery, which can be seen today on the south side from eastbound trains departing Jamaica Station. No photographs are known to exist of the engine house, which appears to be a roundhouse on the map. To the lower right of the engine house sits the Jamaica Gas Company, the site of the large gas tank that can be seen in many photographs taken at the east end of the Jamaica Station area. At the corner of Beaver Street and Fulton Avenue (now Jamaica Avenue) was the Jamaica Hotel, later renamed Pettit's Hotel.

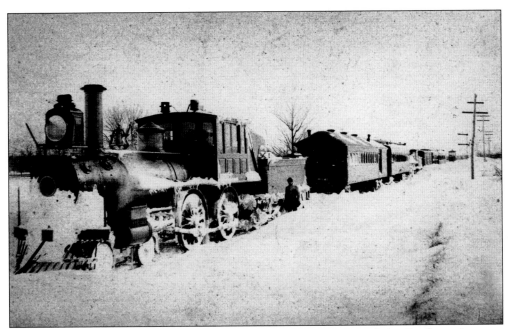

On March 13, 1888, locomotive No. 82 and passenger train were stranded at Rockaway Junction (the area near the present-day Hillside Support Facility) during the infamous blizzard of 1888. (Courtesy of Arthur Huneke.)

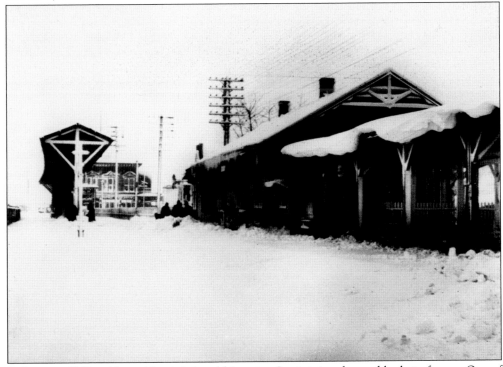

In January 1898, a blizzard buried the old Jamaica Station in a heavy blanket of snow. One of the station platform canopies can be seen at left. The wooden telegraph poles in the background have six cross arms, each carrying four wires. (Courtesy of Carl Ballenas.)

A 4-6-0 camelback locomotive No. 15, built by Baldwin Locomotive Works in 1902, is seen in Jamaica in January 1903. The twin tanks that stored water for the steam locomotives are in the background. A conductor stands in the foreground.

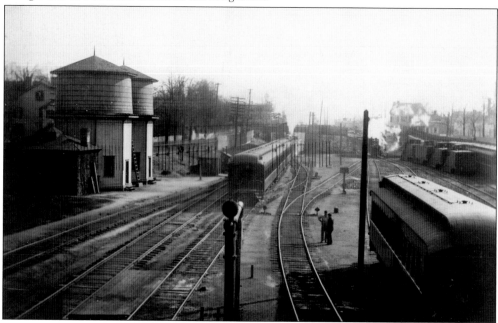

Looking eastward toward the Washington Street Bridge in the winter of 1902 and 1903, the twin water tanks can be seen to the left, and the waterspout is at bottom center. This photograph was evidently taken from the roof of one of the platform canopies. The main line at this time was two tracks.

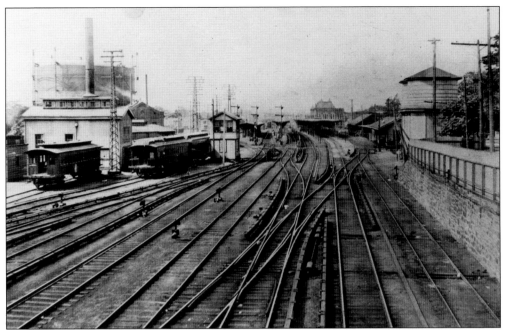

Looking west from the Washington Street Bridge, this photograph shows an excellent view of the old Jamaica Station area. The Jamaica Gas Works is at left. Wooden coaches and a wooden signal tower can be seen nearby. In the distance is the old Jamaica Station, and to the right are the water tanks and Twombly Place. (Courtesy of Arthur Huneke.)

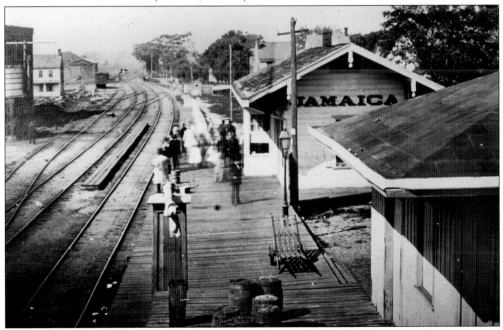

The old Jamaica Station is shown in this 1874 photograph taken from the Beaver Street overpass by G.B. Brainard. The express house is to the right, and the water tank is to the left. The railroad through Jamaica at this time was double track, with a passing siding to the left. Notice that the passenger platforms were wood planking with no overhead canopies.

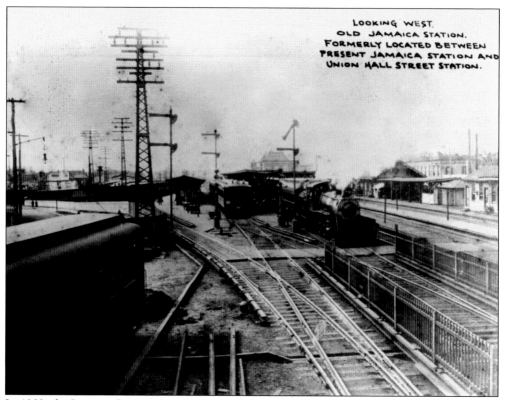

In 1903, the Jamaica Station area was expanded to six tracks, and third-rail electrification was installed in 1905. In this photograph, a steam train can be seen pulling out of the station, and the third rails are in clear view. Twombly Place is in the background at right. In 1904, a pedestrian underpass was installed between Twombly Place and Beaver Street.

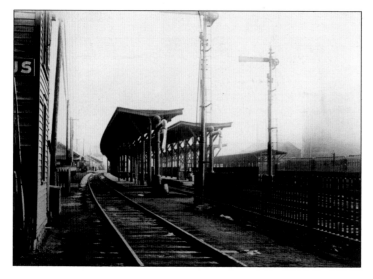

JS Tower is visible at far left in this December 19, 1908, photograph taken at the west end of the platforms on the north side of the tracks. This tower, formerly Tower No. 40, was renamed in 1907. Shortly after this photograph was taken, it reverted to a gate tower and the call letters were removed. (Courtesy of Emery Collection, Stony Brook University.)

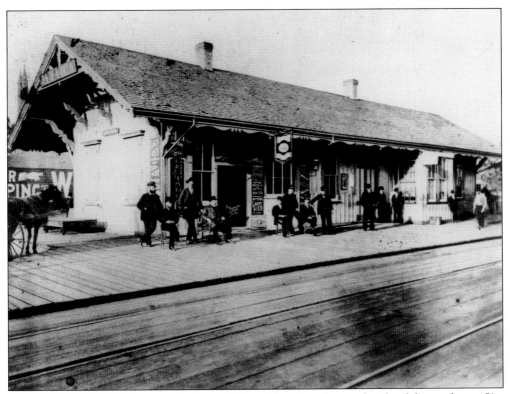

The old wooden LIRR Jamaica Station building located on the north side of the tracks at 151st Street dated back to pre–Civil War days. In May 1877, the South Side Rail Road Beaver Street depot was moved to a location west of the LIRR's building. The SSRR building (above) was used as a lunchroom and beer hall. The photograph below shows the orientation of the buildings. The SSRR building is in the foreground, beyond it is the LIRR building, and in the distance is the Beaver Street roadway overpass bridge. (Both courtesy of Arthur Huneke.)

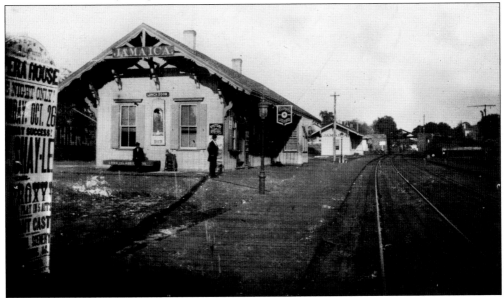

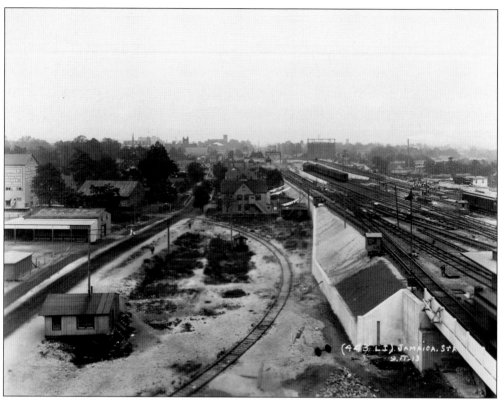

In 1855, John Adikes established a wholesale and retail grocery, specializing in farm and garden seeds, in Jamaica. His business was served by an LIRR siding that ran from the west end of the station area along what is now Archer Avenue, crossed what is now Sutphin Boulevard, and curved northeast to the Adikes facility. The above view was taken from the roof of the newly built Jamaica Station building. The image below shows a steam train servicing the siding. (Below, courtesy of Carl Ballenas.)

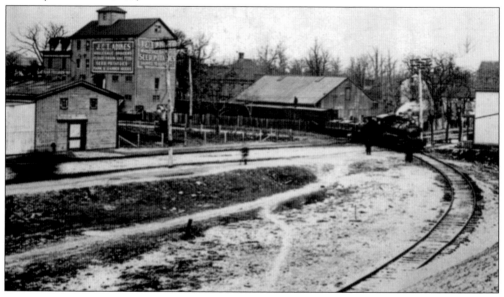

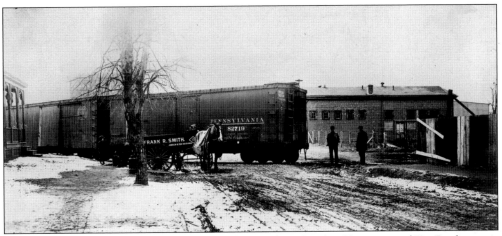

On the Adikes siding, a farm wagon owned by Frank R. Smith of Jamaica and Far Rockaway is seen next to the wooden Pennsylvania Railroad car 82719. Notice the high hand-brake wheel at the end of the car. The blanket on the horse and the snow on the ground indicate that this is a winter scene. (Courtesy of Emery Collection, Stony Brook University.)

Potato farming was an important industry on Long Island in the early 1900s. According to the May 14, 1910, *Brooklyn Daily Eagle*, Long Island farmers planted 12,500 acres of potatoes in the spring and shipped 560 carloads of the product by rail in the fall. This Adikes ad illustrates the importance of potatoes to their business. Today, potato farming is all but extinct on Long Island. (Courtesy of Carl Ballenas.)

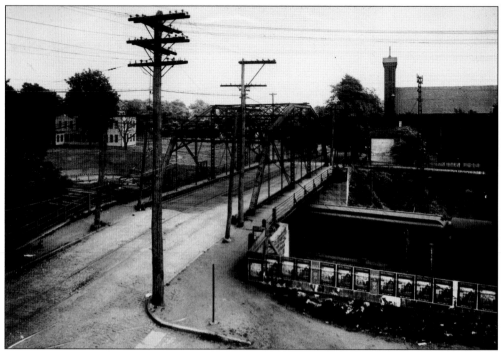

In a view looking south, Washington Street (now 160th Street) crossed over the LIRR on a 107-foot-long steel truss bridge, which also had a trolley car track of the Long Island Electric Railway. The posters on the fence in the foreground advertise a Knights of Columbus fundraising drive—"$500,000 wanted." St. Monica's Church is in the background at right. The turntable can be seen to the left of the bridge.

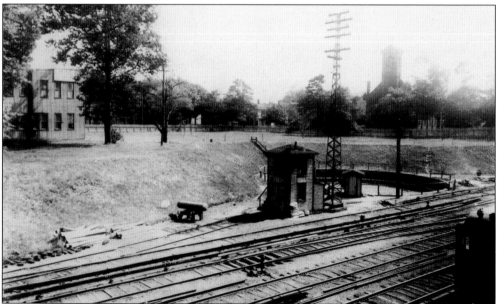

The Washington Street turntable had a few small buildings nearby. The larger of these had double doors at ground level for the storage of a track inspection car. In the background at right, St. Monica's Church is faintly visible. These tracks were equipped with electric third rails.

Locomotive No. 524 is being moved onto the turntable as the crew looks at the photographer from the cab. This was an Armstrong-type turntable that was moved by manpower. The turntable pit was lined with brick. At one time, the LIRR had 17 turntables on the system. A westbound train of wooden passenger cars can be seen at right.

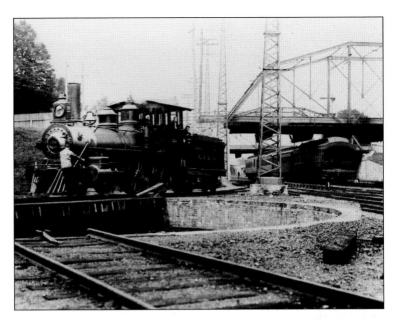

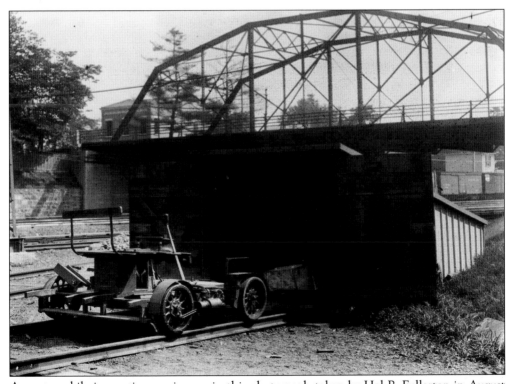

An automobile inspection car is seen in this photograph taken by Hal B. Fullerton in August 1905. The track ended at the base of the storage shed, which meant that the car had to be lifted by hand and placed in the shed. (Courtesy of Ron Ziel.)

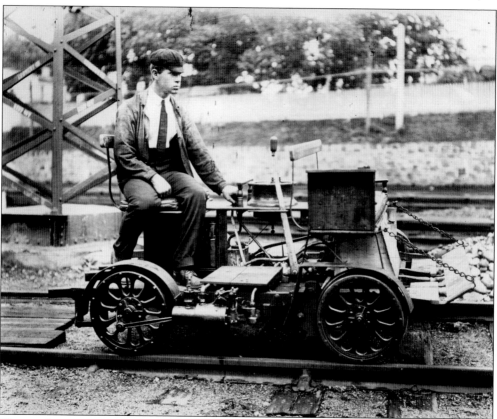

This track inspection car was a primitive interior combustion vehicle with the cylinder directly attached to the wheel. The operator posed for this August 1905 photograph taken by Hal B. Fullerton. (Courtesy of Ron Ziel.)

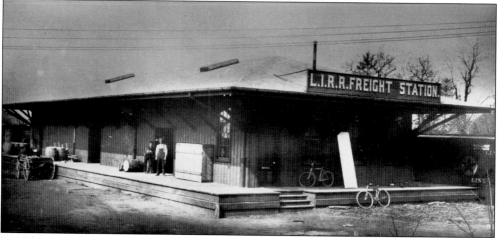

In addition to its passenger station, Jamaica was served by a separate building for the handling of freight. It was here that freight items were received from and delivered to wagons. At this single-story, wood-frame structure with a wraparound platform on all sides of the building, freight was handled by railroad freight cars on one side and by wagons on the other side. (Courtesy of Emery Collection, Stony Brook University.)

Two

EARLY STREET SCENES

AND GRADE CROSSINGS

The Long Island Rail Road helped to make Jamaica a thriving center of commerce on Long Island in the late 1800s and early 1900s. During its early years, most of the tracks were on the same level as the streets, creating numerous grade crossings, which created the potential for countless collisions with pedestrians and horse-drawn wagons and carriages.

Moreover, the LIRR was not the only railroad in the village. The South Side Rail Road (SSRR) entered Jamaica in 1867, running from Brooklyn to Patchoque and the Rockaways. The SSRR crossed over the LIRR in Jamaica, and each had its own train station. The LIRR station was closest to the village center, while the SSRR station was a short distance southwest on Beaver Street.

After the 1876 merger of the two railroads, the Beaver Street Station was no longer needed and the building was moved to the LIRR main line just west of the LIRR station building, where it served as a lunchroom.

This chapter illustrates the relationship between the village and the railroad, as well as highlighting its numerous grade crossings.

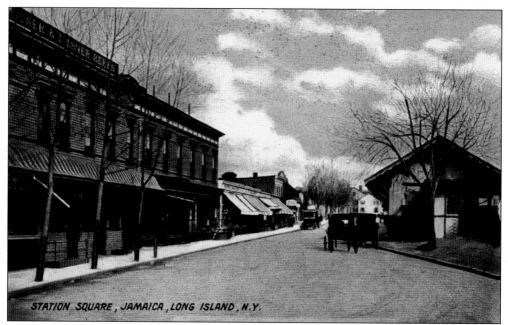

STATION SQUARE, JAMAICA, LONG ISLAND, N.Y.

This c. 1909 postcard view looks east on Twombly Place, with the LIRR depot at right. This wooden depot building was demolished in 1913 upon the opening of the new Jamaica Station building. The railroad opened the Union Hall Street Station in this vicinity so that a nearby train station would still serve the village.

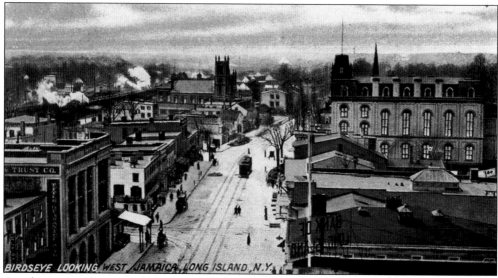

BIRDSEYE LOOKING WEST, JAMAICA, LONG ISLAND, N.Y.

Another postcard view, looking west on Fulton Street (now Jamaica Avenue), shows the Village Hall—the large building with the numerous windows at right. The Dutch Reformed Church can be seen on the left side of Fulton Street; this church building is still there today. At far left are the LIRR tracks, where smoke can be seen emerging from several steam locomotives. (Courtesy of Carl Ballenas.)

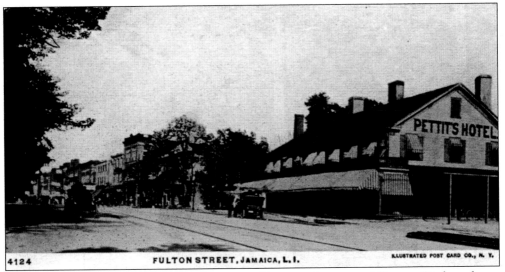

Pettit's Hotel, located at the southwest corner of Jamaica Avenue and Parsons Boulevard, was a block away from the old Jamaica train station on Fulton Street. According to local historian Carl Ballenas, this hotel was one of Long Island's oldest roadhouses. On July 21, 1900, the *New York Times* reported that "George Washington slept here."

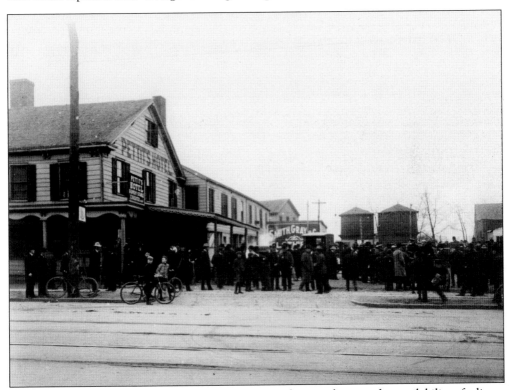

This view shows Pettit's Hotel, with a sign on the overhang indicating the availability of a livery stable. In the distance are the two water tanks that were located at the railroad station. These are the same water tanks seen in the photographs on page 18. The Joseph P. Addabbo Federal Building now occupies the former site of Pettit's Hotel. (Courtesy of Carl Ballenas.)

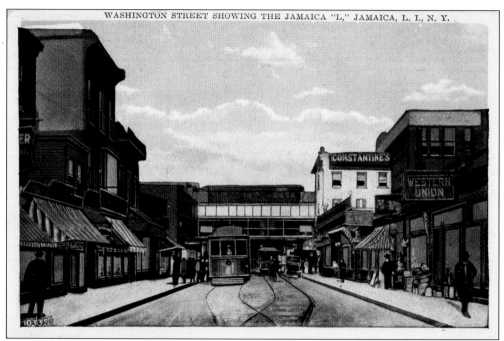

This postcard view shows Washington Street, looking north toward the Jamaica "L" subway line. A Western Union telegraph office is to the right, and a Long Island Electric Railway trolley car is approaching. A view looking south on this same street can be seen on page 24.

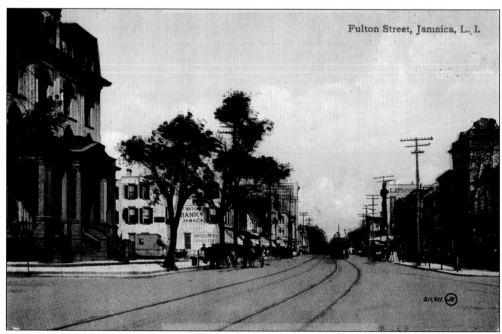

Fulton Street, Jamaica, L. I.

The Village Hall is to the left in this image looking east on Fulton Street. This building was razed in 1941. LIRR officials undoubtedly carried out much business here with local politicians during the years of the Jamaica Station improvements.

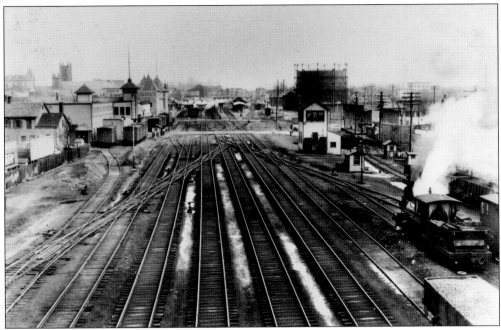

These two photographs, taken in 1904, should illustrate why the LIRR had to do something to eliminate the street grade crossings in the old Jamaica Station area. Above is a distant overview of the entire station area looking east. The old wooden signal tower No. 15 controlled the switches on the west end. Beyond the tower is the original gas tank, later replaced by a more modern one. The steeples of the Dutch Reformed Church and the Village Hall can be seen in the distance to the left. Division Street crosses the six tracks nearest the station, and Rockaway Road crosses the six tracks nearest the tower. Below is a closer view of the Division Street grade crossing. The gate watchman's shanty is at the extreme left.

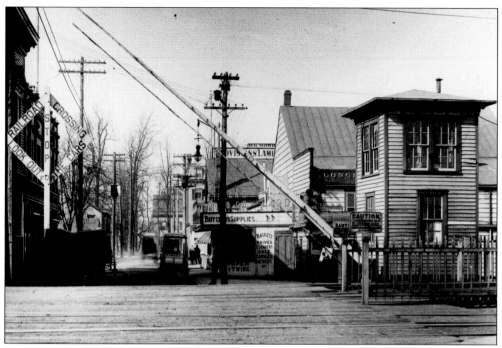

This December 29, 1908, photograph shows the Division Street crossing with its nearby clapboard tower. On the fence posts, there are heavy cast-iron signs warning of the electrified third rails. A diamond-shape grade crossing sign, the type that used to be seen all over Long Island, is at left. Horse-drawn wagons are visible on the dirt road. (Courtesy of Ron Ziel.)

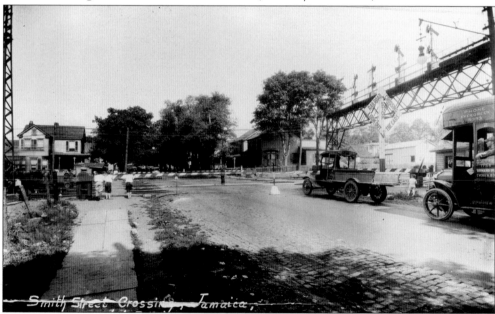

This undated photograph shows trucks at the lowered gates of the Smith Street crossing, which was six streets east of the old Jamaica Station. The semaphores can be seen on the signal bridge at right, as well as the crossing watchman's shanty, which is mostly hidden by the truck. The watchman is standing on the tracks between the downed gates.

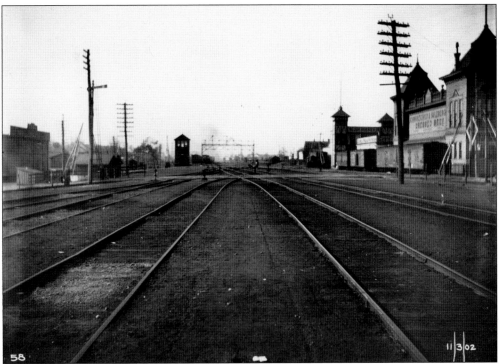

Both of these photographs were taken in the same approximate vicinity, east of the old Jamaica Station. The above photograph is dated November 3, 1902, and shows the track just west of the station, facing west. The signal tower in the distance is the same tower seen on page 31. The tracks of the old South Side Rail Road go off to the left. The nearest grade crossing is Division Street. The 1913 photograph below was taken at the Beaver Street crossing, looking northwest. Note the wooden electric poles in the above image and the steel poles in the photograph below.

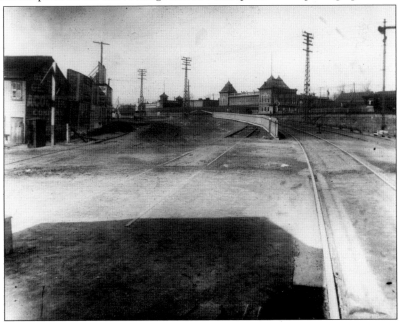

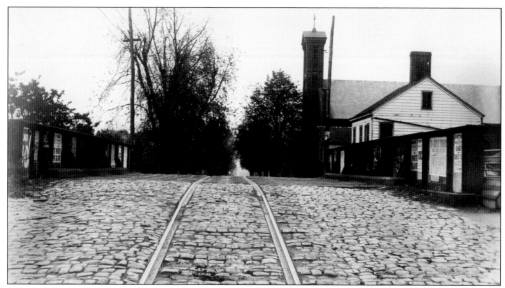

The Washington Street Bridge (which also appears on page 24) is seen from street level in this photograph from October 28, 1902. The roads approaching the bridge were made of granite paving blocks, while the bridge deck was made of wooden planks. The steeple of St. Monica's Church is in the background. This building was placed on the National Register of Historic Places in 1979. Sadly, much of the building collapsed on March 9, 1998, but the facade was saved. In what is known in architectural terms as a "facadectomy," a new building was constructed behind the facade. It is now a structure on the York College campus.

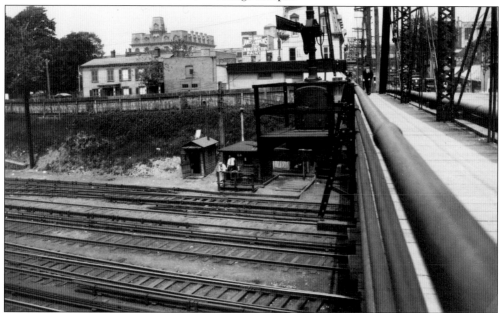

This is a view from the Washington Street Bridge, looking northwest during the Jamaica Improvement Project. The Village Hall is in the background at left. The larger of the two trackside structures is cabin No. 7, which was put into place during the project and lasted until the 1930 Jamaica East Improvement. The smaller structure was probably an outhouse. (Courtesy of Arthur Huneke.)

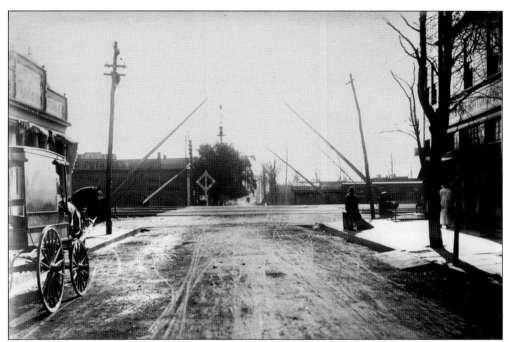

The second crossing west of the old Jamaica Station was Rockaway Road, seen in these two photographs from November 3, 1902. Shown above is the view looking south along the dirt road. Notice the hitching post near the curb at the right side of the photograph. The building across the tracks on the left is one of J.T. Adikes's facilities. Below is the same road, looking north. Meatpacking companies are on each side of the road, and the freight car across the tracks to the right of the railroad crossing sign reads "International Packing Company."

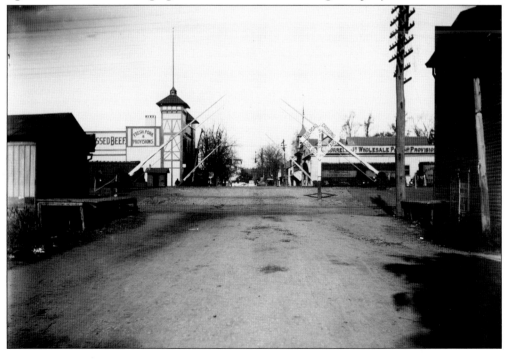

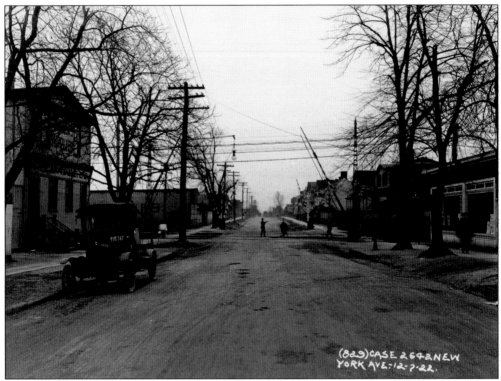

These photographs from December 7, 1922, show cross streets filled with automobiles rather than the horses and wagons seen in previous images. These photographs were taken after the Jamaica Improvement Project of 1913 but prior to the Jamaica East Improvement of 1930. Above is the New York Avenue crossing at grade. This street is now called Guy Brewer Boulevard. Below is Union Hall Street, with a dirt road leading up to the steel truss bridge going over the tracks. The writing on the side of the truck at left reads, "JAMAICA BREAD—largest concentrated circulation." The sign on the gas pump seen behind the bread truck reads, "SOCONY MOTOR GASOLINE."

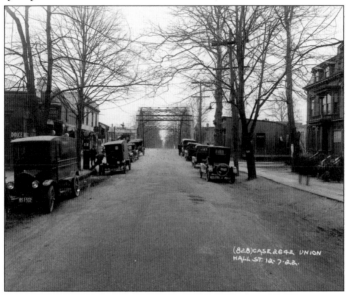

Three

PLANNING AND CONSTRUCTION

In the late 1800s, Long Island City was the most important station on the Long Island Rail Road, with Jamaica a close second. It soon became apparent to railroad management that Jamaica Station was quickly becoming inadequate in serving the rapidly expanding railroad system. Thus, in the 1890s, the LIRR made extensive purchases of land from 130th Street (Morris Park) to Sutphin Boulevard. The freight yard was expanded to 26 tracks at that location.

In 1903, four tracks were added to the old station and an underground pedestrian passageway was installed. Yet, due to the increase in passenger train traffic, the station was still inadequate.

Plans were made to build a larger station, as well as an office building to house the railroad management and staff that worked in Long Island City and at various buildings in the Jamaica area.

The plan was to elevate the entire station and, thus, eliminate the numerous problematic grade crossings. However, the area of the old station did not allow for further expansion because the village was on the north side and the Prospect Cemetery was on the south side. A decision was made to build a new station half a mile west of the old one. This would require a massive construction project involving the installation of fill, retaining walls, underpasses, steel overpasses, and a new brick station building.

Fortunately, photographs of the construction work exist in the archives of railroad historian Arthur Huneke. This chapter contains a sample of the photographs in Huneke's collection, which he generously loaned to enhance this book.

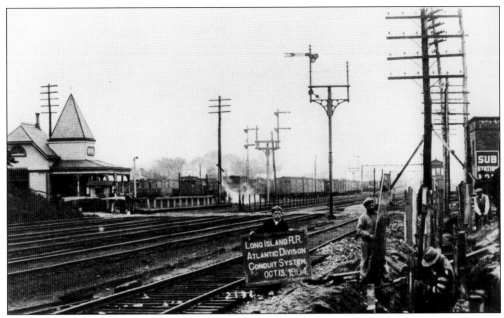

There are few photographs over 100 years old that may be exactly dated. This one, taken on October 13, 1904, is an exception. It was taken during the laying of conduit for the electrification of tracks to Jamaica Station. At left is Dunton Station, which was between the Morris Park Shops and Jamaica Station. This is the same building seen on page 71. The road going across the tracks is the Van Wyck Avenue grade crossing.

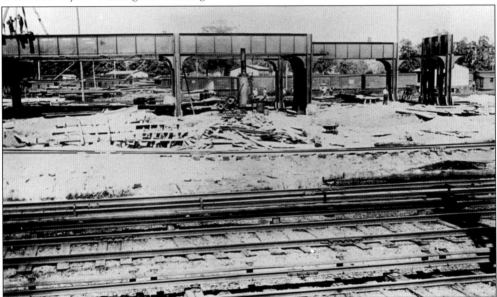

Looking north on what was to become Guilford Street (and is now Sutphin Boulevard), this September 28, 1911, photograph shows the steelwork being erected to carry the railroad over the street. To the left, just out of view, was the Jamaica Station building. The large opening on the left was for the southbound lanes. The opening in the center was for the northbound lanes, the opening to the right was for the sidewalk, and to the extreme right is the location where the elevators were installed.

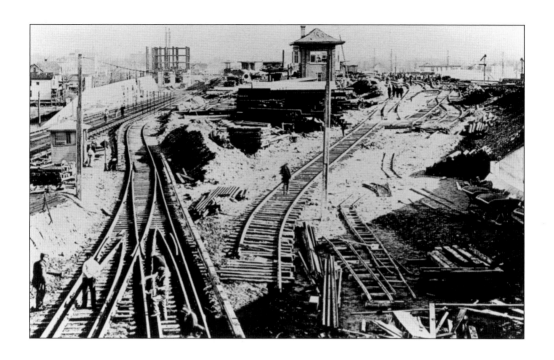

Above, Jay Interlocking is under construction in this December 3, 1912, photograph. The station platform canopies can be seen in the distance, to the immediate left of the tower. And, to the left of the canopies, a rare sight is visible in this one-of-a-kind photograph: the steel skeleton of the Jamaica Station building. This is the only known image of the building under construction. There must have been numerous photographs taken as the building went up, but they have evidently been lost over time. Below is an enlargement of the building area shown in the above photograph.

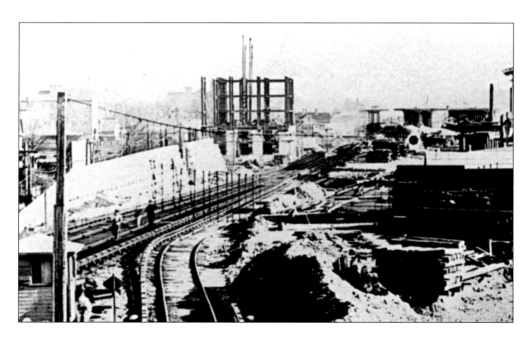

In this August 23, 1912, photograph, looking north on Van Wyck Avenue, the elevated LIRR tracks cross over the roadway. The road (some say "Van Wike"; others say "Van Wick") was named after Robert A. Van Wyck, the first mayor of unified New York City. In the early 1950s, the road was designated an expressway, but in reality, it is a long parking lot.

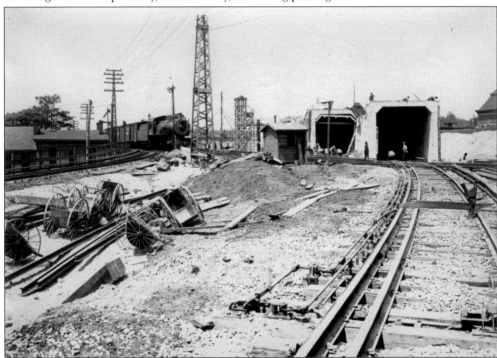

The Atlantic Branch under-jump seen here is undergoing construction as an eastbound freight train runs on the temporary main line. The under-jump allowed trains bound for Long Beach, Far Rockaway, and West Hempstead Branch to pass underneath the main line tracks. The switches at this location were controlled by a block operator, whose office was in the shack, or cabin No. 5, as it was called.

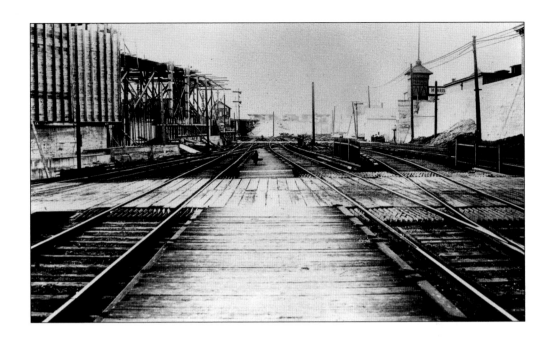

These two photographs show the north wall of the Atlantic Branch under-jump during its construction. Above, the view looks west from the old station. Beyond the construction work is JT Tower, and barely visible beyond that are the new, raised, station platforms. Below, the view looks east toward the old station platforms. This photograph was taken in the vicinity of JT Tower. The overhead bridges for Prospect and Washington Avenues can be seen in the distance.

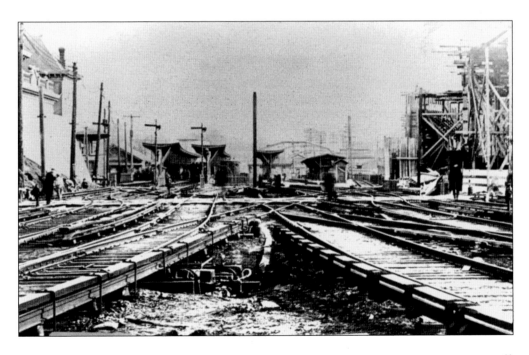

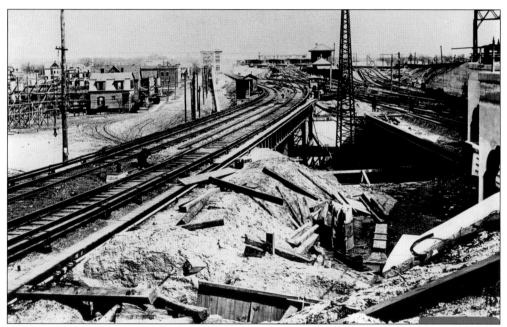

Looking east in this March 7, 1913, photograph, the new station is visible beyond the new J Tower (later renamed "Jay"). The old, temporary, ground-level New York tracks are at far left. In the middle is the 1910 bridge over Van Wyck Avenue.

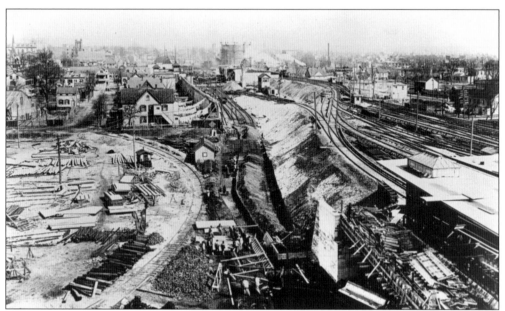

This photograph, taken from the roof of the new station building, gives an interesting perspective on the track elevation work and how it was progressing. The newly elevated tracks are to the right, the partially elevated tracks are in the center, and the temporary New York ground-level tracks are to the left. The curved track at far left is the Adikes siding. The platform A elevator skylight can be seen at far right.

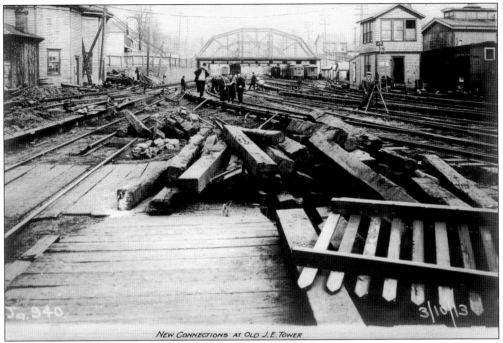

NEW CONNECTIONS AT OLD J.E. TOWER

In this view looking east from the old station, a surveyor is at work in front of JE Tower (Jamaica East). The railroad's gas plant, which later became part of Jamaica Gas Works, is at far right, and the railroad's water tanks are at far left. The overhead bridges for Prospect and Washington Streets can be seen in the center background.

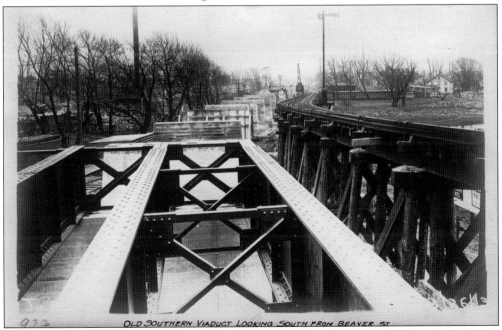

OLD SOUTHERN VIADUCT LOOKING SOUTH FROM BEAVER ST

Looking south from Beaver Street, the new steel and the old wooden southern viaducts lie side by side. The new viaduct now carries the tracks of the Atlantic Branch for trains traveling to Far Rockaway, Long Beach, and West Hempstead.

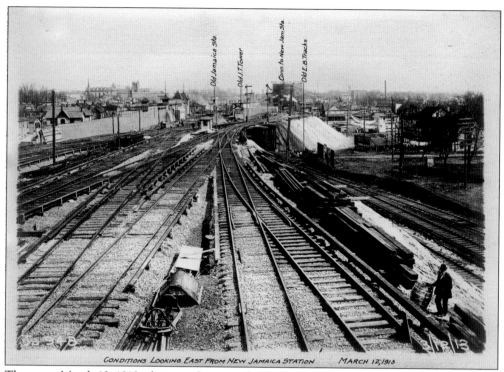

CONDITIONS LOOKING EAST FROM NEW JAMAICA STATION MARCH 12, 1913

These two March 12, 1913, photographs are probably the most dramatic in terms of showing the nature of the work that was performed during the Jamaica Improvement Project. Above, the old eastbound ground-level tracks are to the right, and the new, elevated tracks coming into the station are in the center. The old station is in the distant center, and the Village Hall and the steeple of the Dutch Reformed Church can be seen in the distance to the left. Below, the old westbound tracks are to the right, and the new elevated station is to the left. J Tower is at a distance in the center, and to its left, the Dunton Electric car shop is faintly visible.

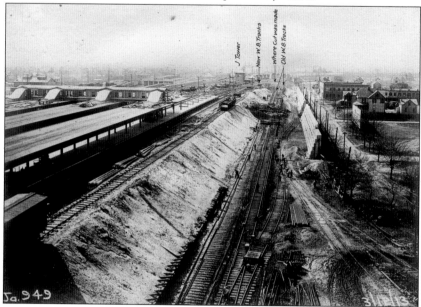

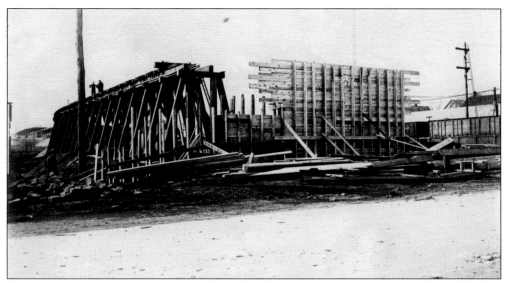

Looking west, part of a temporary wood trestle bridge into the new station is visible at left. One of the new station platforms is at the far left of the photograph. The construction project was performed without interrupting the flow of train movements, which required construction of temporary wood viaducts and tracks to permit the on-time movement of regular trains. Tracks were shifted as the work progressed.

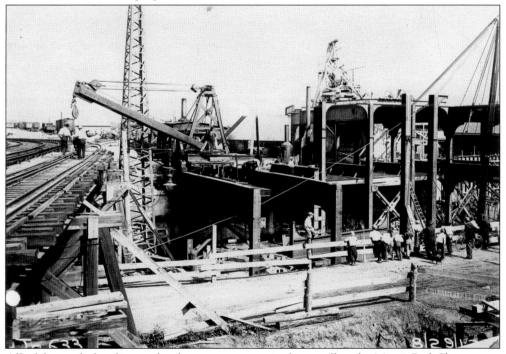

All of the tracks heading to the three western terminals, as well as the Morris Park Shops, cross over Van Wyck Avenue on a multilevel steel viaduct, which can be seen under construction in this photograph from August 29, 1913. The Van Wyck viaduct is actually three separate bridges on two levels, which carry 13 tracks over the newly widened roadway. The viaduct is 200 feet wide, allowing for a 100-foot-wide roadway below.

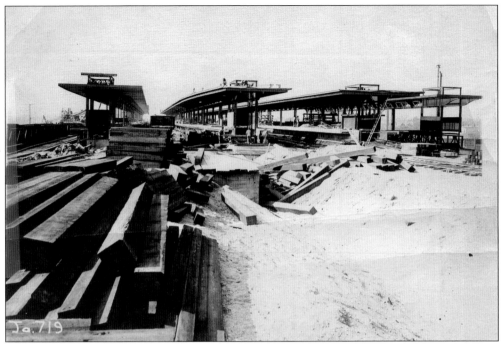

The new station has five, 1,000-foot-long platforms that were built to accommodate 16 cars on each of the eight platform tracks. The platforms are seen here during the construction phase. This view looks west, showing the east end of the platforms, which each had an express/baggage elevator with skylights in the roof. The umbrella sheds covering each platform were of steel construction, with timber roofs covered with tar and gravel.

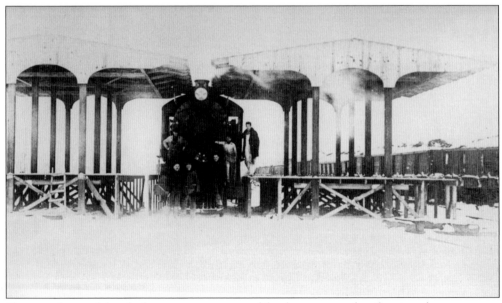

Short mock-ups of the platforms were constructed for the purpose of performing clearance tests. A crew posed on a Camelback locomotive for a photograph during one of the tests.

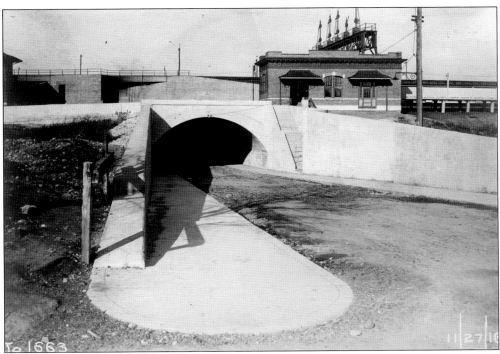

As part of the Jamaica Improvement Project of 1913, numerous grade crossings were eliminated by girder bridges or cement archways. In this November 27, 1916, photograph, the cement arch that allowed Maure Avenue to go under the railroad right-of-way is pictured with Dunton Station in the background. Also known as an under-jump, this structure was 32 feet wide and 510 feet long. Like Sutphin Boulevard, this street did not cross the railroad until completion of the 1913 improvement project.

During 1929 and 1930, the LIRR embarked on another project, known as the Jamaica East Improvement. This project involved the elimination of six grade crossings by raising the right-of-way for approximately one and a quarter miles. An interesting feature during this project was the use of old cross ties as cribbing to serve as retaining walls to hold the earthen fill in place. In this image from April 21, 1930, the cribbing is seen supporting the newly elevated right-of-way.

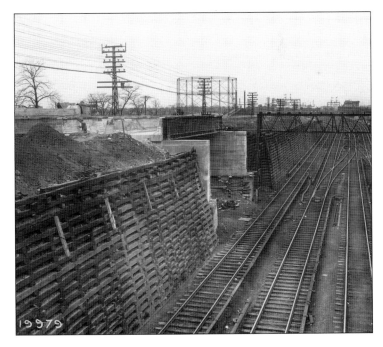

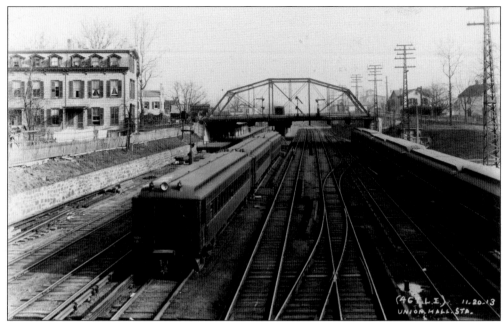

In 1913, Union Hall Street depot was opened two-thirds of a mile east of the new Jamaica Station to serve the people of the village, who had complained that the new station was too far away. This November 20, 1913, view shows a westbound Brooklyn Express train departing the station. Union Hall Street is carried over the tracks by the steel truss bridge.

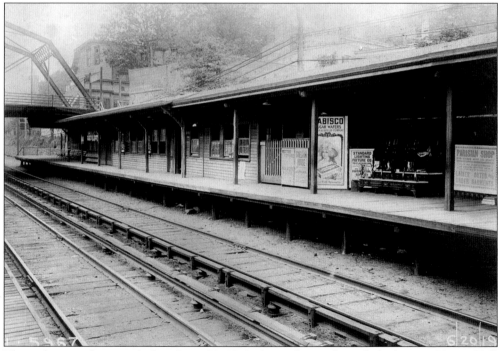

This valuation photograph from June 20, 1919, shows the eastbound platform at Union Hall Street. A shoe-shine stand can be seen at right, as well as a display board advertising Nabisco Sugar Wafers. The Union Hall Street Bridge is at far left.

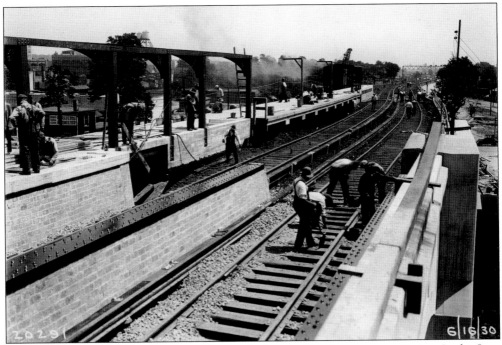

Union Hall Street Station was elevated during the Jamaica East Improvement Project. In this June 16, 1930, photograph, workers are seen erecting the steel supports for the platform canopy.

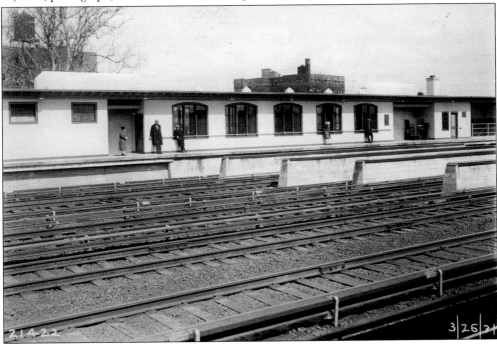

As part of the project, the right-of-way was expanded from six to eight tracks through the area. Union Hall Street Station, seen here in a March 26, 1931, photograph, was abandoned as a station stop in 1976 due to low usage. The street level arch is now an entrance to York College, and a facade was placed above the arch to mimic the old station.

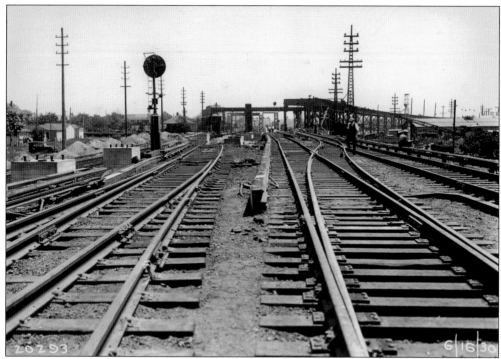

A major aspect of the Jamaica East improvement was the construction of a 1,920-foot steel viaduct to carry the tracks of the Babylon/Montauk branch off from the main line, thereby eliminating crossover switches at Rockaway Junction. The viaduct was built over Hillside Station, which was opened on May 15, 1911, to serve the residents of Jamaica Estates and closed in 1966. The area near Rockaway Junction and Holban Freight Yard is now the site of the Hillside Maintenance Facility, the LIRR's main repair shop, located just east of where the viaduct curves southeast. These two eastward views show the viaduct under construction in 1930.

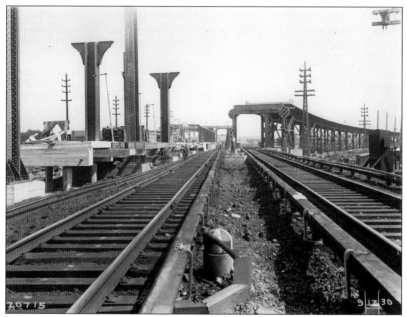

Four

JAMAICA STATION
BUILDING AND PLATFORMS

The current Long Island Rail Road station and headquarters building in Jamaica has two main entrances. The entrance for passengers is on the east end of the building, facing Sutphin Boulevard. The employee/executive offices entrance is on the north side, facing Archer Avenue. There is a common passageway between the entrances.

The Sutphin Boulevard entrance has a marquee going across the full width of the building, just above the first floor level. There are two sets of double doors leading into the waiting room. Originally, the waiting room was two stories high and the ticket office was of the island type in the middle of the waiting room. In the early 1950s, a major renovation took place, wherein a second floor was added above the waiting room and a new ticket office was built on the north wall. In 1972, the ticket office was again moved, this time to its present location facing the Sutphin Boulevard doors.

On the south side of the waiting room, doors lead to a stairway going up to the mezzanine. Stairways on the mezzanine give access up to the trains, which are served by five platforms (designated by the letters "A" to "E"), or down to street level.

The Archer Avenue entrance has one double-door entry. Above the second floor line, there is a large stone placement with the name "Long Island Rail Road Co." in metal letters and carved cornucopias on each side of the placement.

The building is five stories high, although the original design (see page 56) provided for eight stories. No record can be found as to why the height of the building was reduced from the original plans. The building exterior is faced with stone on the first two levels and brick above that. There is an overhang with supporting brackets above the fifth floor.

The railroad president and staff have offices on the upper floors. The building houses the Train Movement Bureau, as well as the Electrical Load Dispatcher. In essence, the entire LIRR system is run from the Jamaica Station building.

This chapter will explore the building that is considered the "nerve center of the Long Island Rail Road."

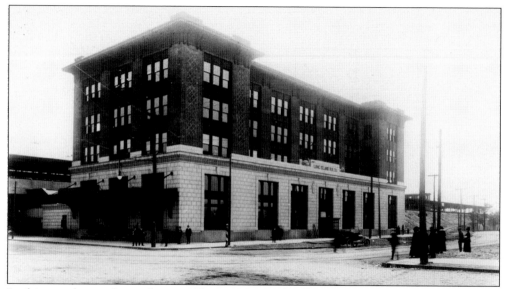

Looking southwest, the newly opened Jamaica Station building is pictured here. The intersection of Sutphin Boulevard (in the foreground) and Archer Avenue was a dirt road, as seen in this 1913 photograph. The building, which cost the LIRR $235,000, was designed by architect Kenneth M. Murchison. (Photograph by Fred J. Weber.)

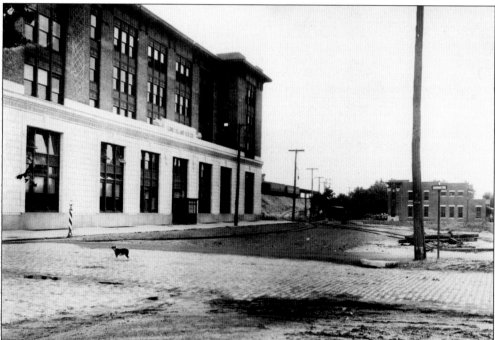

In another view, looking southwest, the intersection is partially paved with granite blocks. The track running in front of the Archer Avenue entrance is for Adikes siding, which crossed Sutphin Boulevard. A train can be seen on the elevated station tracks behind the building. To the far right is the trainman's building of similar design to the station building. The barber pole and the dog provide added interest to this scene. Until the late 1990s, there was a barbershop on the first floor of the station, off of the waiting room. (Photograph by Fred J. Weber.)

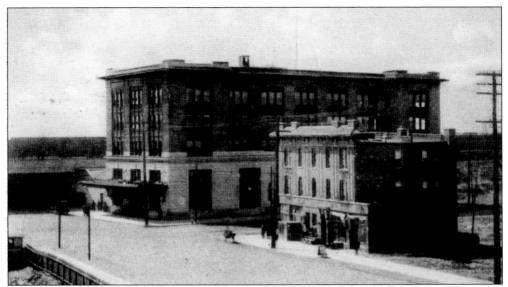

Six years after the building opened, the area around Jamaica Station started to build up, as shown in this 1919 postcard view. A new building with stores on street level and apartments above was erected across from the station on Archer Avenue. A partial view of a construction site can be seen in the left foreground.

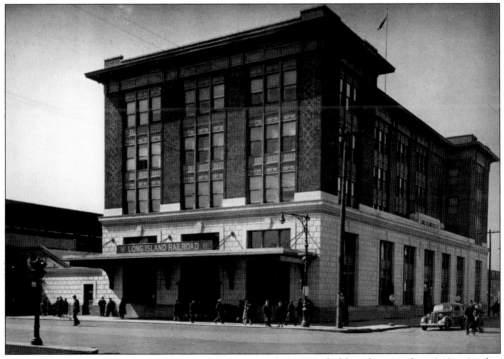

Judging by the automobile, this undated photograph was probably taken in the 1940s. At this time, the railroad's name was on a sign over the marquee. Stone keystones can be seen above the windows. These keystones run around the building and are the emblem of the LIRR's former parent company, the Pennsylvania Railroad. Also notice the diamond patterns in the brickwork at the building corners.

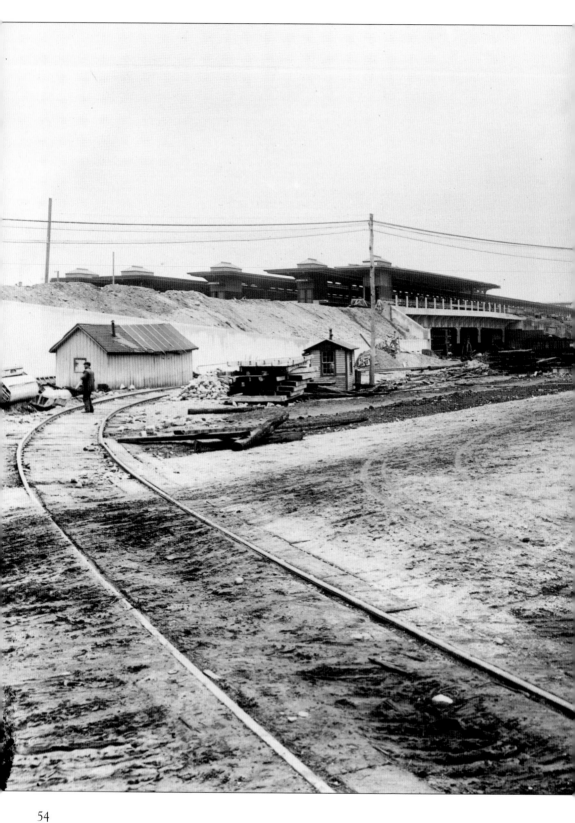

This panoramic view, looking southwest, shows the Jamaica Station building during the construction period. Notice the cement retaining walls that hold the earth fill in place. The five platforms, with the raised elevator skylights, can be seen at left. Beneath platform A, closest to the building, the Sutphin Boulevard bridge construction is visible (compare this with the photograph on page 38). A wagon drawn by two horses is on the Archer Avenue street side. A track leading to the Adikes facility is directly in front of the camera. This photograph was made from a glass plate negative. (Photograph by Fred J. Weber.)

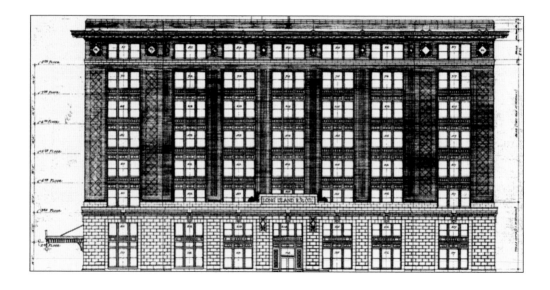

The architectural drawing above, referred to as the "North Elevation" and dated August 25, 1910, shows the Archer Avenue office entrance. The 1910 design provided for a building eight stories high, although the steel skeleton was designed for a twelve-story building. The basic features of this drawing were incorporated into the final building, but there are some differences, especially at the roofline. Below is an enlarged area showing the Archer Avenue entrance. The LIRR has kept "rail road" as two words in its spelling of the corporate name. In the 1990s, the MTA wanted to change the name of the railroad to something like "Metro East," but the president, Charles W. Hoppe, insisted that the name not be changed. Thanks to his efforts, it remains the Long Island Rail Road. (Both courtesy of Long Island Rail Road.)

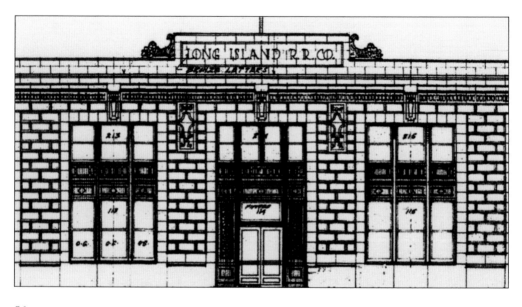

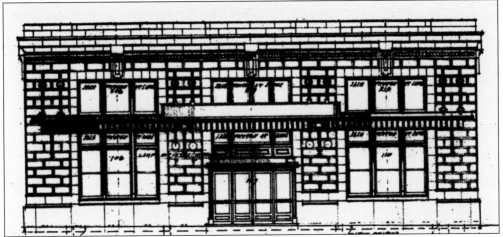

This drawing of the Sutphin Boulevard entrance shows a panel for the station name on top of the marquee. In later years, that panel was removed and, ironically, the name of the railroad does not appear at the main public entrance to the station. This marquee stretches the full length of the building and is supported by four, large, steel brackets below and eight chains above. (Courtesy of Long Island Rail Road.)

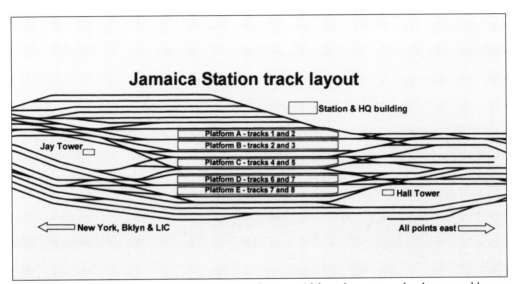

This drawing shows the track layout at Jamaica Station. Although not to scale, the general layout of the building, platforms, and the two main signal towers can be seen. The tracks at upper left are passenger car storage tracks known as yard D. For the purpose of simplicity, the platform overpasses are not shown. (Courtesy of Ronald Zinn.)

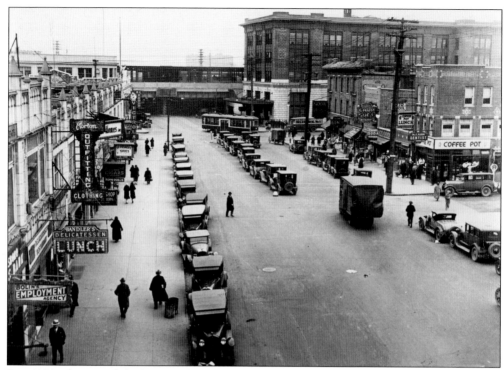

In a 1930s photograph looking south on Sutphin Boulevard from the elevated subway station, a trolley can be seen rounding the corner at the Jamaica Station building. The station platforms and the Sutphin Boulevard underpass are in the distance. (Courtesy of New York City Library.)

In a view looking north from the station platform, this 1972 photograph shows Sutphin Boulevard. A subway train can be seen on the Jamaica Avenue elevated line. This line was abandoned and the structure demolished in the 1980s. The Queens County Supreme Court building is visible in the distance. (Courtesy of Richard Glueck.)

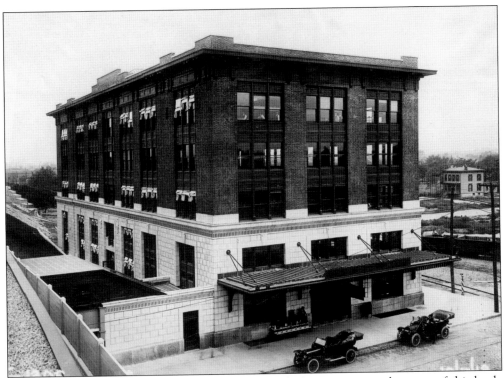

This is a full view of the October 7, 1913, photograph that appears on the cover of this book. The roof for the stairway leading from the waiting room to the mezzanine can be seen at left. A shoe-shine stand and a mailbox are in front of the building, and two automobiles are parked at the curb. The lone house in the distance at right underlines the remoteness of the location.

This postcard view shows the waiting room/mezzanine stairway structure from a different angle than the previous image. From the mezzanine level, separate stairs led to each of the five platforms. There were several food vendors and a newsstand on the mezzanine. In the late 1990s, the food vendors were removed and the newsstand relocated to the waiting room. At the far end of the mezzanine was the lost-and-found facility.

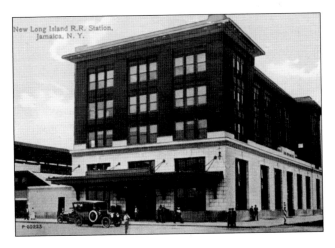

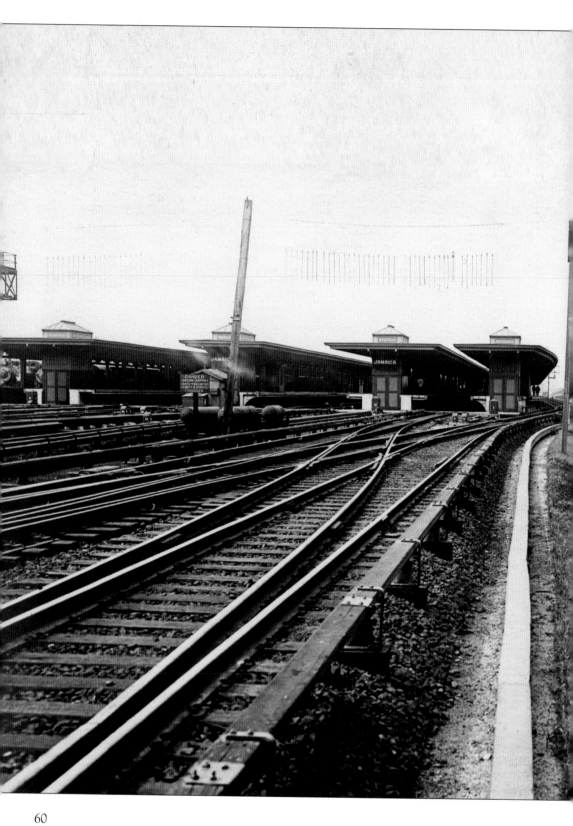

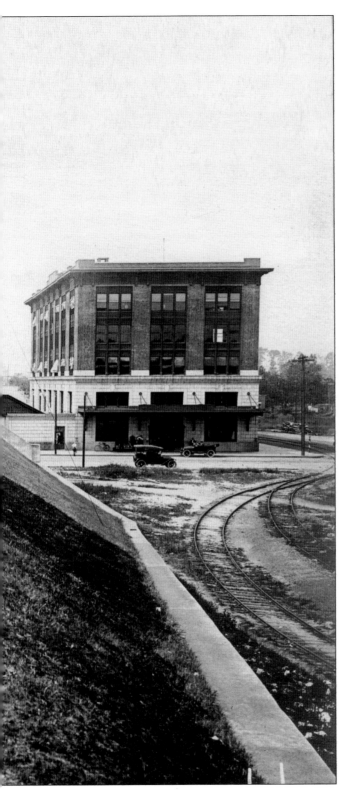

Looking west, this September 6, 1916, photograph has several interesting features. At the extreme upper left, a portion of the eastbound signal bridge, with two semaphore signals, is visible. Below the bridge, two steam locomotives are ready to haul eastbound passenger trains out of the station. The two vertical poles support a telltale that is stretched across the westbound station tracks. A telltale is a series of ropes across the tracks that are placed at the height of a boxcar. The ropes give warning to any brakeman riding on top of the cars that the train is approaching a low clearance obstacle—in this case, the platform canopies. At the base of the left pole, there are gas storage cylinders and a sign that reads, "Smoking, carrying lights and fires in this vicinity is strictly forbidden." These tanks most likely stored gas for the switch heaters.

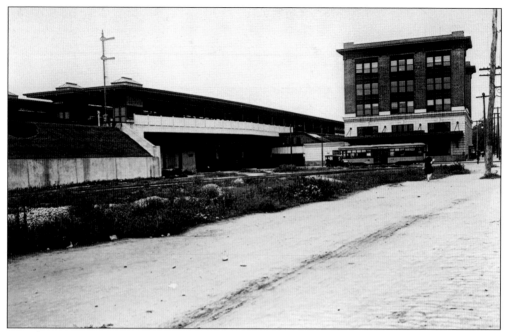

The Manhattan and Queens Traction Company started running trolley service to Jamaica Station in 1914. Unlike most trolleys running at the time, this line extensively used center-door cars equipped with double trucks, with motors on each truck. One of those trolleys is seen paused in front of the Sutphin Boulevard entrance to the station. (Courtesy of the Ron Marzlok collection, Carl Ballenas.)

The pay train is a thing of the past on the LIRR. This 1913 photograph shows the pay train on Archer Avenue. Employees from the station building would board the pay train to receive their wages. In the background is a billboard advertising "Fletcher's Castoria." The pay train was abolished on June 9, 1924.

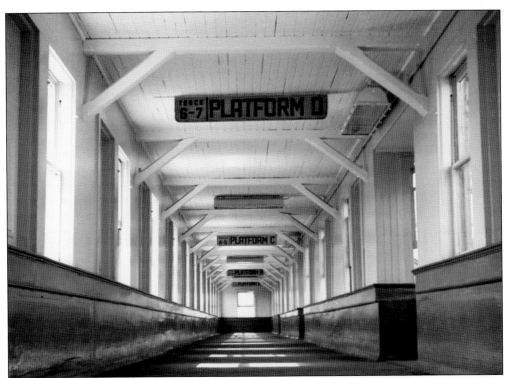

These pictures depict some rather rare interior images of the station. The 1971 photograph above shows the interior of the Jamaica Station west-end overpass, which was constructed of all wood. At right is a photograph that appeared in the January 1953 *Long Island Railroader*, an LIRR employee news magazine. The Big Brothers Movement sponsored a Christmas train display in the station waiting room. The area below the "Merry Christmas" sign is where the ticket office is today. (Above, courtesy of Richard Glueck.)

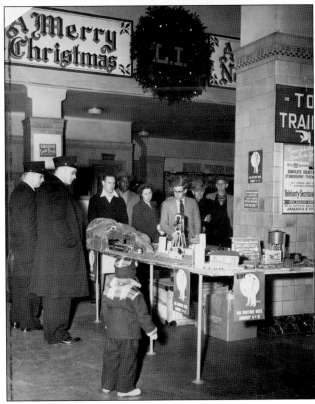

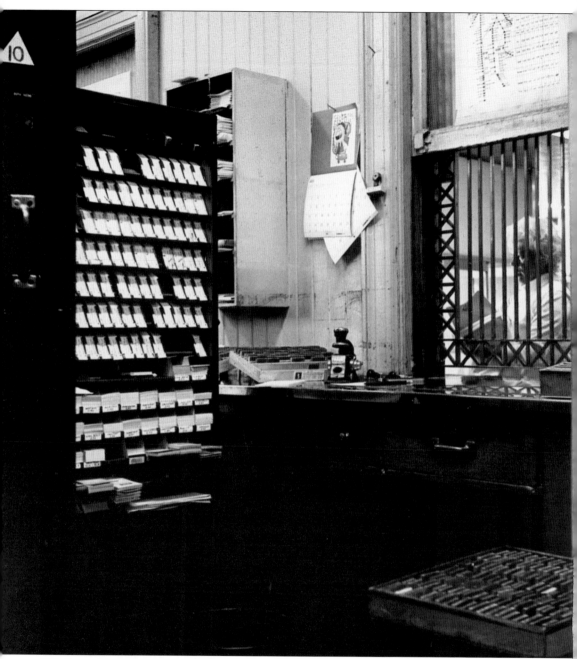

While working as a seasonal ticket clerk in 1972, David Keller took a few photographs inside the ticket office and waiting room—fortunately, as these are the only such photographs known to exist. This view shows a ticket clerk's operating area. The high, freestanding, wheel-mounted ticket case is on the left. The ticket-validating machine is on the counter. To the lower right is the box containing the various rubber stamps. The cash is kept in the drawer below the ticket window. A system map is mounted over the ticket window. (Courtesy of David Keller.)

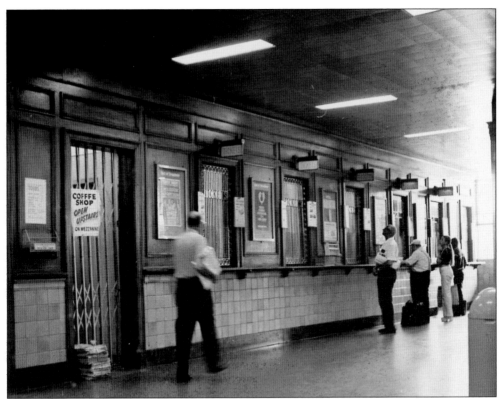

The ticket office was once on the north wall (Archer Avenue side) of the waiting room. There were five ticket windows. A metal, cage-like grate covered the front of each window. The word "TICKETS" was embedded in the window grating. Above each window was a lamp covered by a "TICKETS" sign that was lit up when the window was open. In 1972, the ticket office was moved to its current location. (Courtesy of David Keller.)

This rare photograph is the only image known to exist showing the original Jamaica Station waiting room. There was an island-type ticket office in the middle of the two-story-high room, but in the early 1950s, a second floor was constructed. The Sutphin Boulevard doors are at far left. (Courtesy of Janet Greenstein Potter.)

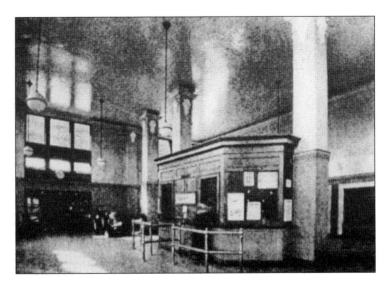

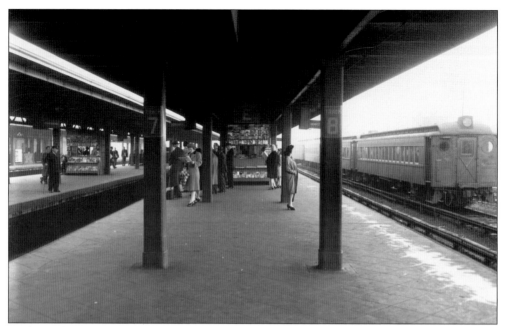

Fred J. Weber was the LIRR's legal department photographer for the first half of the 1900s. He photographed all of the grade crossing accidents, employee injuries, and other incidents. His earlier photographs were shot using 8-by-10 glass plate negatives, but after 1921, he used 4-by-5 film negatives, examples of which can be seen on this page and the next. These photographs were taken on the Jamaica Station platforms in 1947 and show the newsstands that used to be on the platforms.

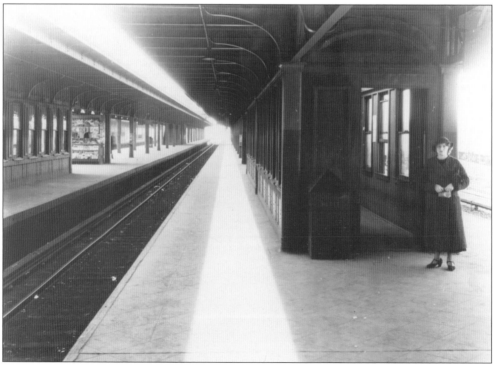

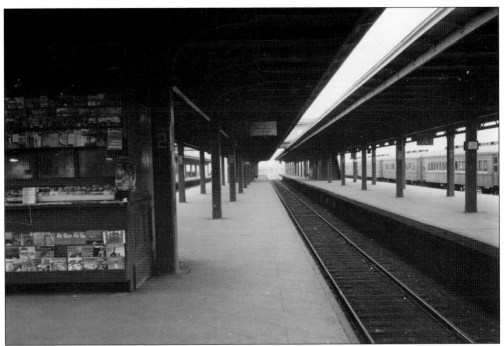

Here are two more Weber photographs of the station platforms. The above image shows a closer view of the newsstand on platform B. The metal pull-down destination sign on platform D is seen in the image below. These signs were replaced in the 1980s by electrically operated signs. The wheelhouse where the usher would make public address announcements is at left. These wheelhouses were supposedly pilot cabins obtained from scrapped tugboats.

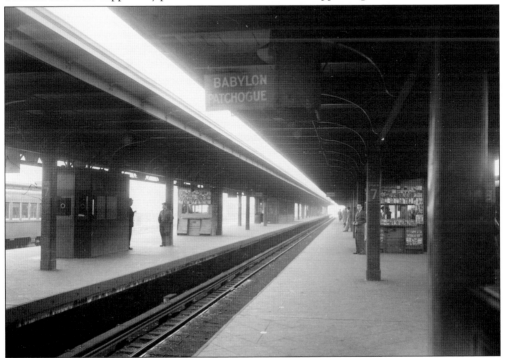

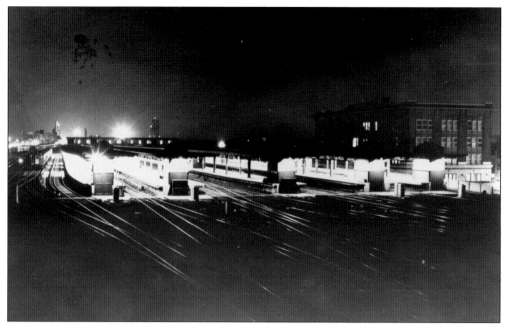

Not too many photographers attempt nighttime views, but Gene Collora took some outstanding photographs after dark. On September 20, 1958, Collora photographed Jamaica Station after sunset. Above, the platforms are lit up while most of the station's lights are out. Below, Fairbanks-Morse C-liner locomotive No. 2005 is ready to pull an eastbound passenger train out of track No. 8. The doors at the lower end of the platform are for the express/baggage elevator. (Both courtesy of Gene Collora.)

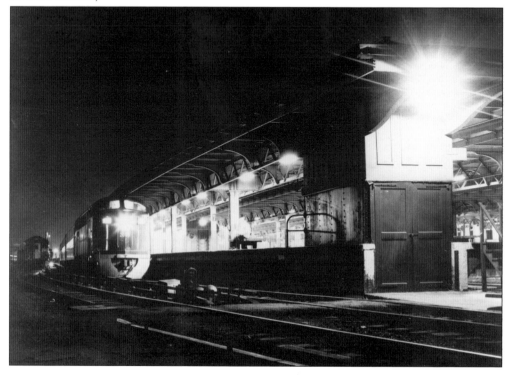

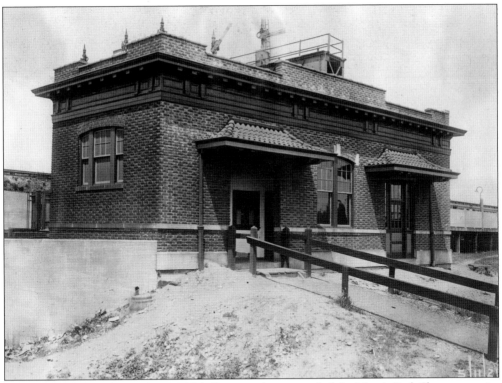

Dunton Station was located near 130th Street at the east end of the Morris Park Shops, opposite Dunton Tower. The station, opened in 1914, consisted of high-level concrete platforms on each side and a building that had a roofline that resembled that of the Jamaica Station building. The station was closed on November 1, 1939, in conjunction with the Atlantic Branch grade crossing eliminations. The May 11, 1921, valuation photographs on this page show the resemblance of the Dunton Station building to Jamaica Station.

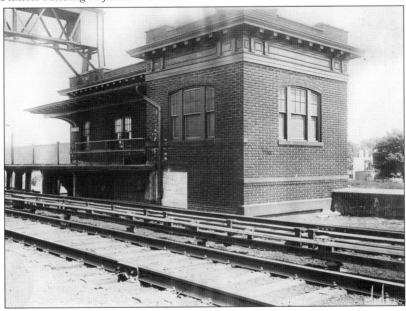

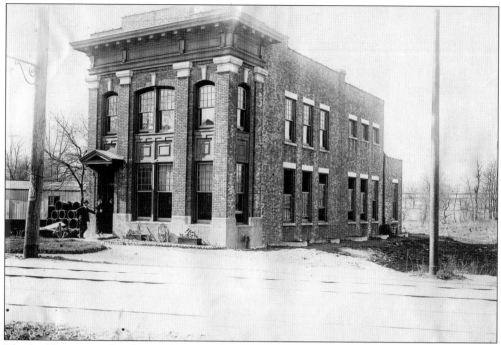

This building, erected at the same time as the Jamaica Station building, was located across Archer Avenue, to the west. It served as the welfare facility for the train crews and resembled a miniature Jamaica Station. In later years, when the crew room was relocated to the first floor of the station building, this facility housed a tailor shop on the first floor and had office space upstairs.

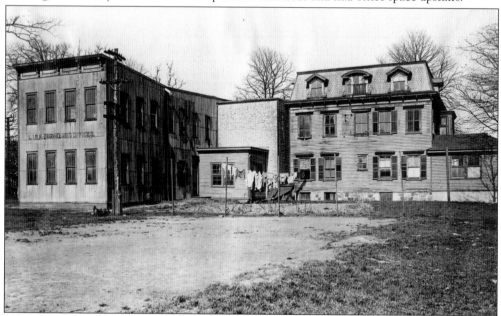

The engineering work for the massive Jamaica Improvement Project was done in this building located near 160th Street. The engineering department was located in Long Island City until 1902, after which it was displaced because of the Penn Station tunnel project. Once the Jamaica Station building opened, the department moved to the fourth floor, where it has remained.

The original Dunton Station building, seen here in an April 2, 1921, valuation photograph, was built in a Queen Anne architectural style. A new brick building was erected in 1914 at 130th Street, and the old building was used as an office for the electrical department.

The writing on the reverse side of this 1921 valuation photograph indicates that this building was "Item #154 in Valuation Section #1 – Jamaica Dwelling." Whoever lived here is a mystery. However, this is a piece of Jamaica railroad history.

From its founding to the early years of the 1900s, the LIRR owned many horses for the railroad's express service. This October 1, 1917, valuation photograph shows the Jamaica Express Stable. During the era of horse-drawn wagons, the LIRR employed a full-time veterinarian.

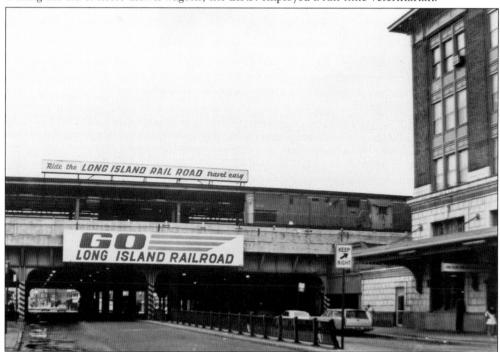

The LIRR had a huge billboard that stated, "GO—LONG ISLAND RAIL ROAD" on the north side overpass at Sutphin Boulevard. These bulletin boards could be seen at other locations, including along the Long Island Expressway in 1975. The locomotive on track No. 1 is an Alco C-420 No. 214.

Five

SIGNAL TOWERS
AND TRACKS

The Jamaica Station track complex allows trains from the east end of Long Island and the south shore to come into Jamaica Station, where passengers may be required to change trains to access the west-end terminals: Penn Station, Flatbush Avenue Terminal (now Atlantic Terminal), and Long Island City (Hunters Point Avenue). The movement of trains through Jamaica is accomplished by a unique system of switches, crossovers, and flyover (over-jump) tracks.

The main signal towers in the complex are Jay on the west end and Hall on the east end. Dunton Tower is at the southwest area and controls trains coming off of the Atlantic Branch from the Flatbush Avenue Terminal and from the Morris Park Shops. Currently, this shop facility is no longer used, and most of the buildings have been demolished. Locomotive and electric car maintenance is now done at the Hillside Maintenance Facility located a few miles east of Jamaica Station.

The signal tower exteriors were designed to resemble the station building. The towers controlled the switches and signals until a few years ago, when a computerized system was put into place at a different location. The towers remain, however, as landmarks to the first century of train operations in Jamaica.

This chapter takes a look at the towers and tracks in the Jamaica Station area.

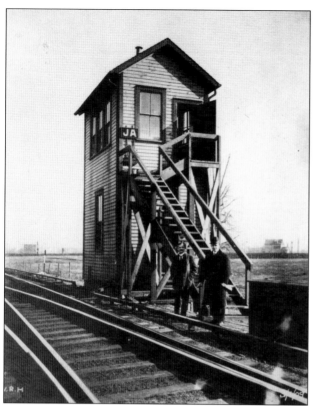

JA Tower was an all-wood signal tower near Van Wyck Avenue. Originally, this tower was given the number 40 but was renumbered 36 in 1903. It was renamed JA in 1907 and again renamed V in 1911. This tower was demolished in 1913 in conjunction with the elevation of the Jamaica Station area. (Courtesy of Emery Collection, Stony Brook University.)

Looking east, Tower 41 is seen at right in a September 1897 photograph that was taken from the Union Hall Street Bridge. At this time, the main line was double track with passing sidings. The sign at left reads, "Notice—walking on the tracks is strictly forbidden." (Courtesy of Arthur Huneke.)

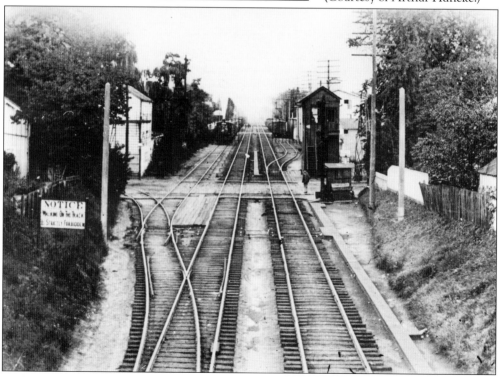

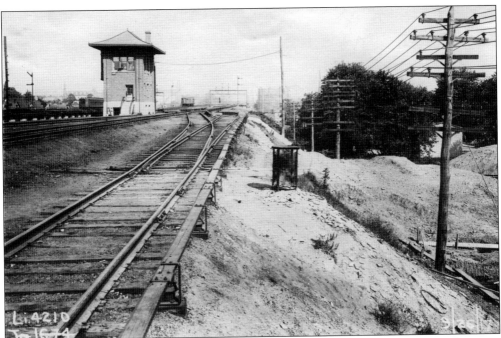

The JE Tower appears in this September 26, 1917, valuation photograph looking east. This tower was renamed Hall Tower in 1937. This is the tower that controls all of the switches on the east end of the Jamaica Station interlocking track system.

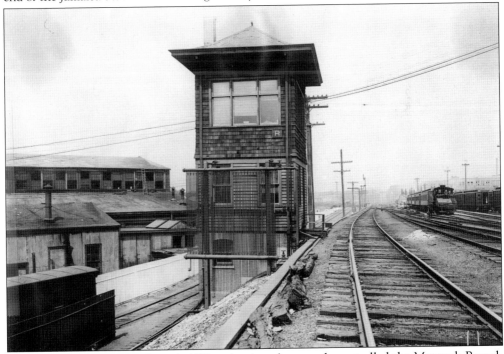

The R Tower seen in this June 1, 1921, valuation photograph controlled the Montauk Branch crossover and westbound connections to Jamaica Station. This tower went into service in 1913 and only lasted until August 16, 1928.

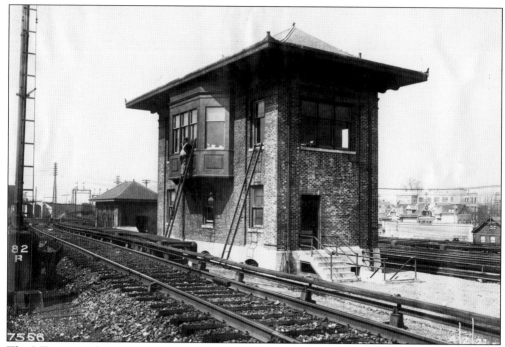

The J Tower is a brick structure located at the west end of the station that was built as part of the Jamaica Improvement Project. This tower was renamed "Jay" on April 16, 1937. The worker on the ladder might have been washing the windows.

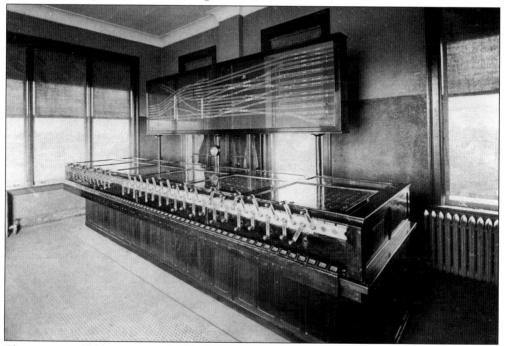

The interior of J Tower is pictured here when it was new. The large board above the switch machine displays the movement of trains through the interlocking tracks at the west end of Jamaica Station.

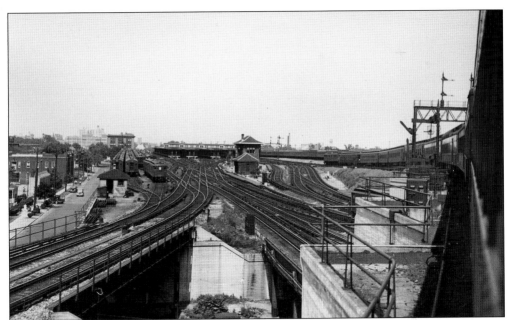

This view, photographed by Rod Dirkes on June 30, 1938, shows Jay interlocking as the eastbound *Cannonball* approaches the station with two electric locomotives on the head end. The *Cannonball* is an all–parlor car train that still runs to Montauk on Friday afternoons. The building in front of Jay Tower is the west-end third-rail switch house. Notice that there is no gas tank in this photograph.

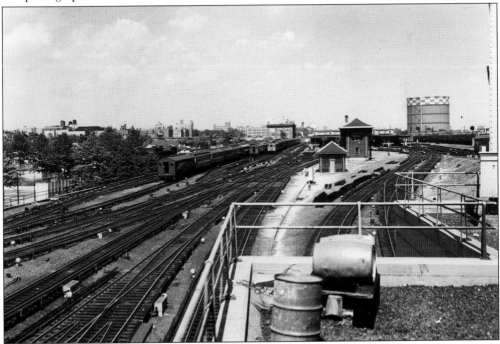

Similar to the previous image, this 1950s view shows the newer gas tank with the checkerboard design on top. This was probably the second large gas tank at this location. It was removed sometime during the 1980s. For decades, this gas tank was both a local and a railroad landmark.

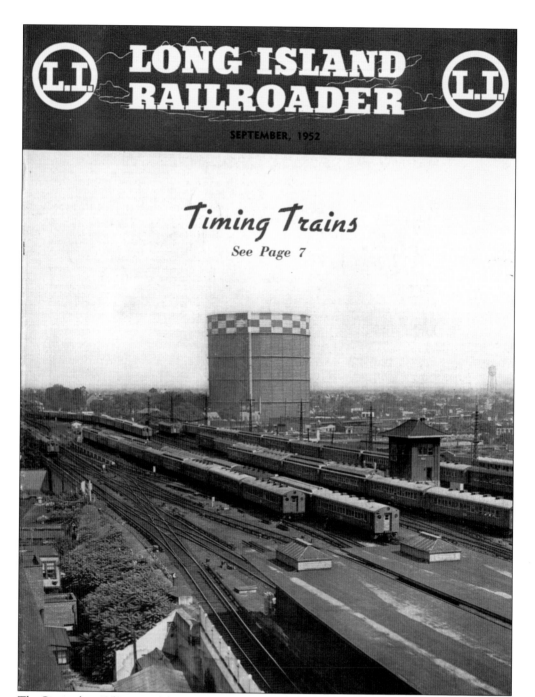

LONG ISLAND RAILROADER

SEPTEMBER, 1952

Timing Trains

See Page 7

The September 1952 issue of the *Long Island Railroader*, the railroad's employee magazine, featured a view of Hall interlocking on the cover. Hall Tower is at right, and the famous gas tank is dead center. The eight trains in this photograph demonstrate the busy nature of this interlocking.

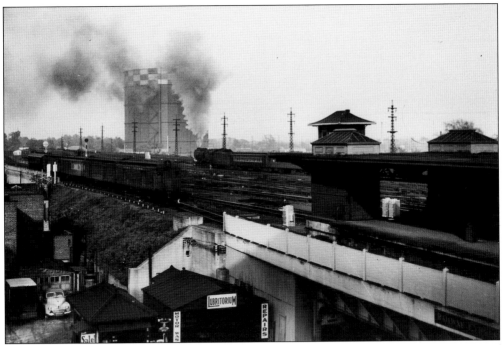

A steam locomotive sends up a plume of smoke as it hauls an eastbound passenger train out of Jamaica Station. At left, an electric MU train is coming into the station on Track 1 with a Railway Post Office car on the head end. This 1949 photograph shows a "Lubritorium" (service station) at bottom center. (Courtesy of Ron Ziel.)

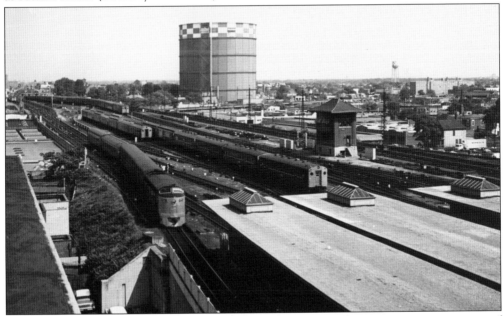

Shot from the roof of the Jamaica Station building, this photograph presents a panoramic view of the east end of the station area. Three landmarks are in view: Hall Tower at right, the gas tank in the center, and, partially hidden behind a grove of trees at left, the steeple of St. Monica's Church. Fairbanks-Morse C-liner No. 2004 is bringing a passenger train into station track No. 1.

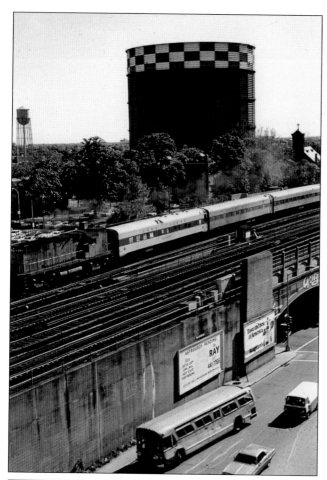

In this July 1971 image, the eastbound *Cannonball* has departed Jamaica Station and is headed for Montauk. This photograph, looking southwest, was taken from the Gertz Department Store parking garage. The bus is on 93rd Avenue, and the underpass is Guy Brewer Boulevard. Union Hall Street Station is out of view to the left. (Photograph by Vincent Alvino.)

Eastbound and westbound passenger trains with Alco C-420 locomotives at the head end move through Hall interlocking in this late-1960s photograph by Vincent Alvino. Most of Vinnie's photographs were shot in 2-by-2-inch color-slide format.

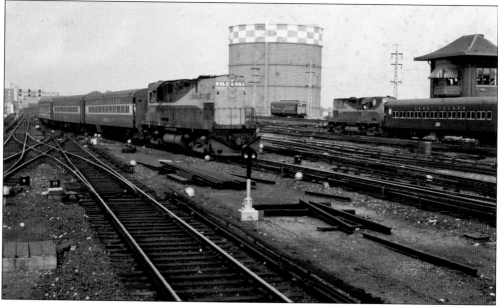

Fred J. Weber took these trackside photographs in Jamaica in the late 1940s. Above, the Jamaica Station building is in a view from Union Hall Street Station, looking west. The roof of Hall Tower can be seen over the first car of the eastbound MU train. Below, this track-level photograph looking east is significant because it gives a view of the Prospect Cemetery at right, with the steeple of St. Monica's Church just beyond.

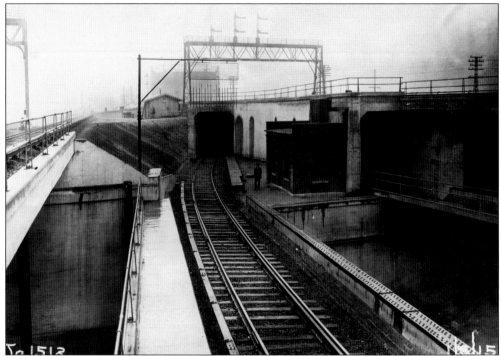

The small buildings pictured in these January 6, 1915, photographs are third-rail switch houses that control the distribution of electrical power in the interlockings. Above is the east-end house located at the west end of the Atlantic Branch under-jump. Below, the west-end house is located immediately west of Jay Tower.

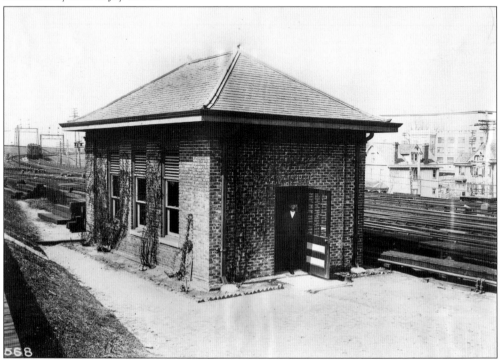

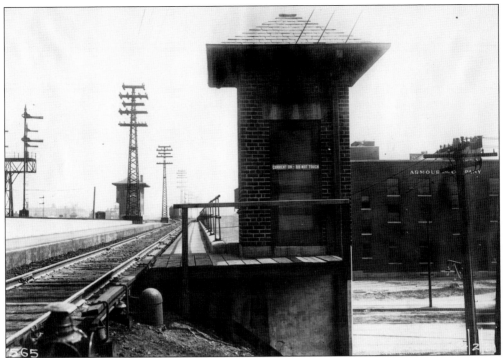

The vulnerability of underground electrical cables for the third-rail system requires the installation of protective equipment. Lightning arresters and choke coils provide protection, and these apparatuses are housed in small huts or buildings. This April 2, 1921, view shows the Sutphin Boulevard arrestor house, with Hall Tower and the Armour Meat Packing building in the background.

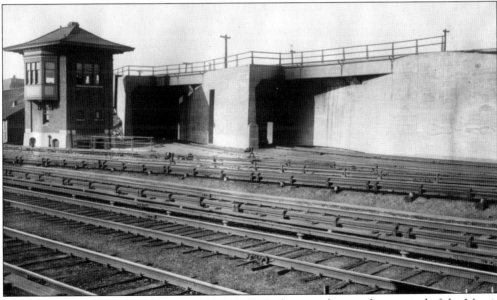

Dunton Tower, pictured in this November 11, 1916, photograph, is at the east end of the Morris Park Shops. The under-jump tracks lead to the Richmond Hill passenger car storage yard. Locomotives coming out of the shop would go past the tower and make a reverse move into the yard to pick up passenger cars.

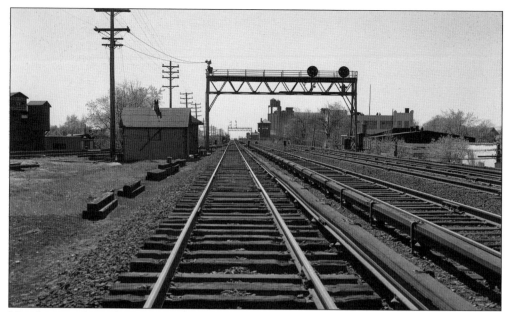

Mainline westbound trains pass through Queens interlocking, which is a system of switches and crossover tracks allowing movement of Hempstead Branch trains onto the mainline tracks. Queens Tower controls the interlocking, which also includes the Belmont Wye. It is located four miles east of Jamaica Station, just east of Queens Village Station. This 1947 view shows the tracks approaching Queens interlocking. The tower is at distant right, and the Hempstead Branch tracks can be seen in the distance at far left. (Photograph by Fred J. Weber.)

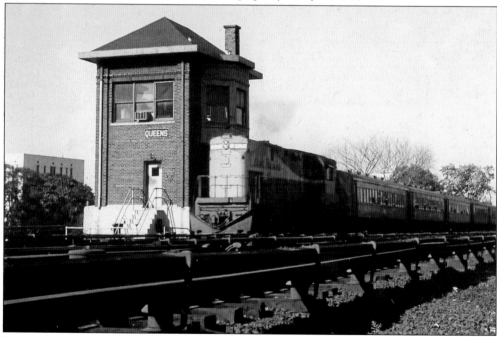

Locomotive No. 217 hauls a westbound passenger train past Queens Tower. The tower, once equipped with a lever-type machine, has been changed over to a microprocessor operation. (Photograph by Vincent Alvino.)

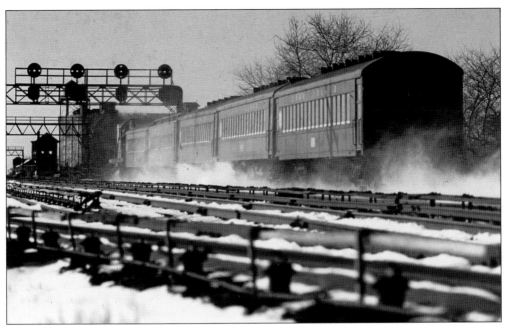

The position light signal has switched to stop as this westbound train kicks up snow while approaching Queens Tower. (Photograph by Vincent Alvino.)

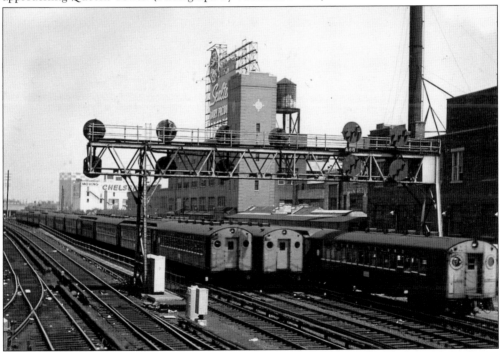

Milk-bottling companies usually had their final processing centers located near their population center markets. Such was the case with Sealtest, which had a large bottling facility on the south side of the tracks at the west end of Jamaica Station. For many older LIRR riders, the Sealtest sign on top of the building was a common sight on their daily commutes. (Photograph by Vincent Alvino.)

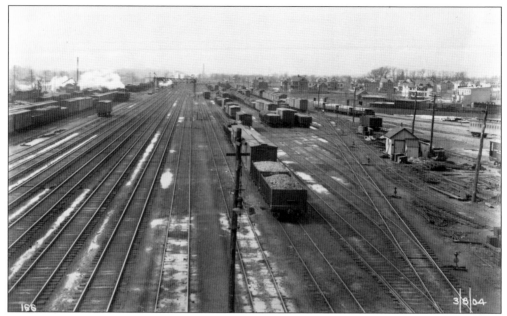

Prior to the 1911–1913 elevation of the entire Jamaica Station complex, there was a 26-track, ground-level freight yard that stretched from Morris Park on the west to Sutphin Boulevard (then Guilford Street). This is a view of the yard, looking west. (Courtesy of Ron Ziel.)

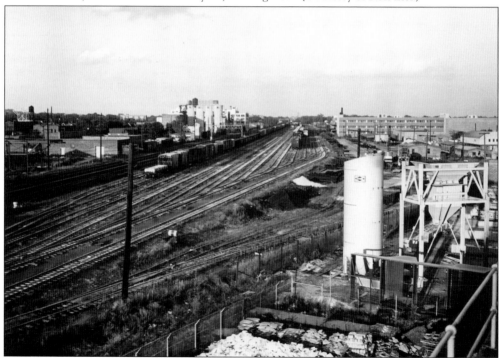

When the LIRR realized that the old Jamaica Station was inadequate and that the best site for a new station would be at the location of the freight yard, plans were made to move the yard farther east. The chosen site was just east of Hillside Station, and it was named Holban Yard. This 1959 photograph shows the Hillside end of the yard. (Courtesy of Ron Ziel.)

Six

TRAINS THROUGH
THE YEARS

As illustrated in Chapter One, the former Jamaica Station saw a variety of old-fashioned steam locomotives. As the years went on, these locomotives got larger and more powerful. In the past, the LIRR was able to lease steam locomotives—such as the E-7 and K-4—from its parent company, the Pennsylvania Railroad. It did, however, own a fleet of G-5s steam locomotives that were the mainstay of passenger service until they were retired in 1955. The G-5s was best suited for passenger service because of its ability to accelerate quickly. There were other types of motive power that the railroad used, such as electric locomotives, diesel locomotives, rail diesel cars, and an array of maintenance-of-way equipment.

In 1905, the tracks were electrified at the old Jamaica Station, and the railroad's first electric multiple-unit trains went through the station. The first electric cars were 41 feet long. Gradually, the electric cars got longer and more sophisticated. The modern M-1 car was introduced after the MTA took over in 1968.

There were, of course, many other types of passenger equipment rolling through Jamaica over the years, like double-deckers, railway post office cars, heavyweight parlor cars, and open-end observation cars.

The LIRR handled freight cars up until the New York and Atlantic Railroad took over the rail freight business in 1997.

This chapter contains photographs of the types of rolling stock that operated through Jamaica Station.

The LIRR leased a large number of steam locomotives from its parent, Pennsylvania Railroad. In this August 1933 photograph, a PRR Class E-7, 4-4-2 locomotive is seen heading into Morris Park, with Dunton Tower in the left background. The Sheffield Farms Company building, which housed a large milk-processing plant, is in the background at right.

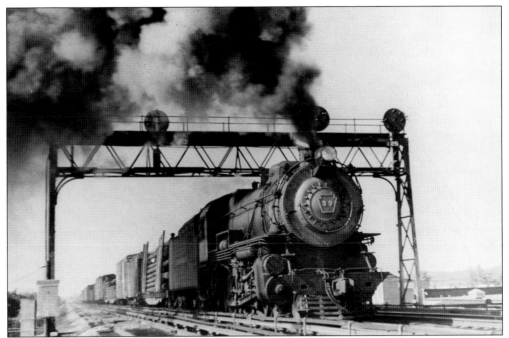

Steam locomotive No. 39 heads a freight train through the Queens interlocking in this 1957 photograph. The car behind the tender is carrying wooden utility poles for the Long Island Lighting Company. This locomotive, along with locomotive No. 35, was saved from being scrapped, and No. 39 is currently part of the equipment collection of the Railroad Museum of Long Island. (Author's collection; photograph by Frank Zahn.)

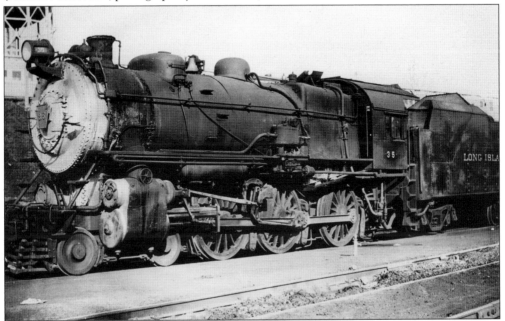

Poised at the entrance to the Morris Park Shops, steam locomotive No. 35 awaits clearance from Dunton Tower. The locomotive is now owned by the Oyster Bay Railroad Museum, which hopes to restore it to operation.

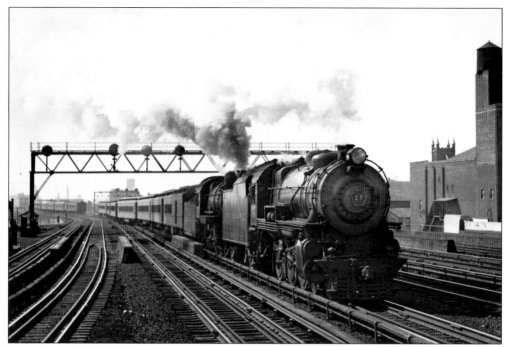

These 1946 photographs show steam-locomotive–drawn passenger trains heading east out of Jamaica Station. Above, locomotive No. 29 leads a doubleheader at Union Hall Street Station. In the left background, an electric MU train can be seen pulling out of Jamaica Station. Below, locomotive No. 23 releases billowing smoke as it heads an eastbound passenger train past the Dutch Reformed Church. Both of these photographs were taken by F. Rod Dirkes, a well-known railroad historian who is now deceased.

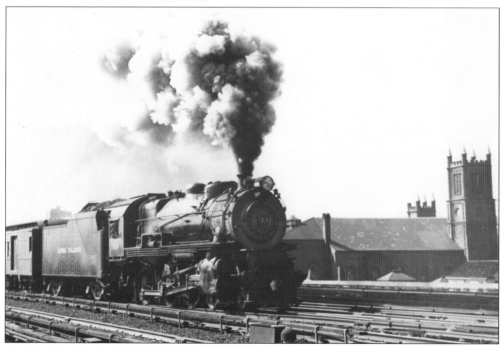

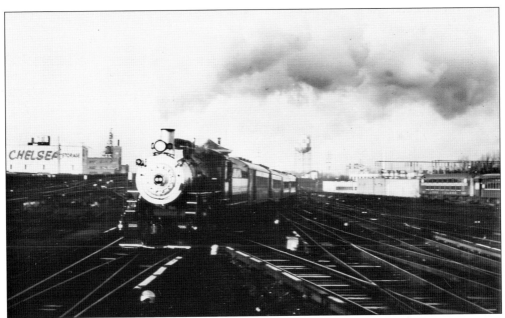

The last steam locomotive to run on the LIRR was owned by the Black River & Western, a tourist railroad based in Ringoes, New Jersey. Locomotive No. 60 was leased for a November 26, 1967, fan trip from Jamaica to Montauk and back. Made up of heavyweight parlor cars and open-end observation cars, the trip was organized by Ron Ziel and George Foster, coauthors of *Steels Rails to the Sunrise*. The locomotive died on the return trip to Jamaica, but it was a day etched in the memory of many Long Island railfans. Above, the locomotive moves east through Jay interlocking as it approaches Jamaica Station. Below, an MP-54 car makes a memorable scene next to the old steamer. (Above, courtesy of Richard Glueck; below, photograph by Vincent Alvino.)

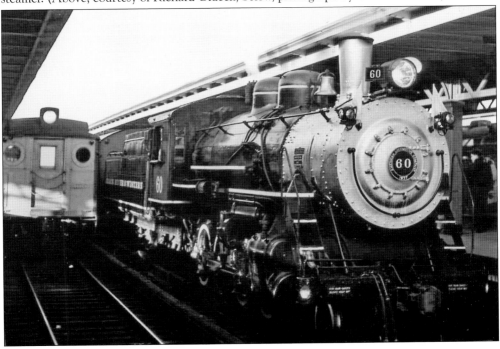

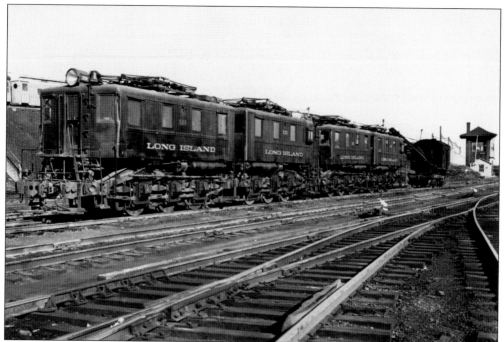

A lineup of four BB-3 electric locomotives is seen west of Dunton Tower in this 1955 photograph. These locomotives were first used on the LIRR in 1927 for service on the Bay Ridge Branch because they were equipped with overhead pantographs. The electric locomotives were retired in October 1955, having been replaced by diesel locomotives.

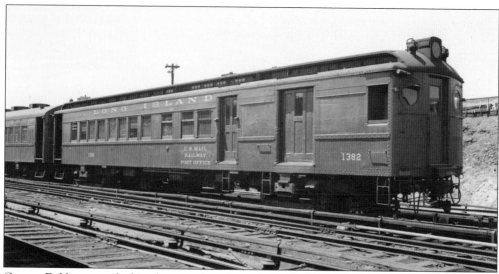

George E. Votava took this photograph in Jamaica on May 12, 1940. The car is an MPBM-54 combination passenger/mail/baggage car. The last day that a railway post office car ran on the LIRR was June 18, 1965.

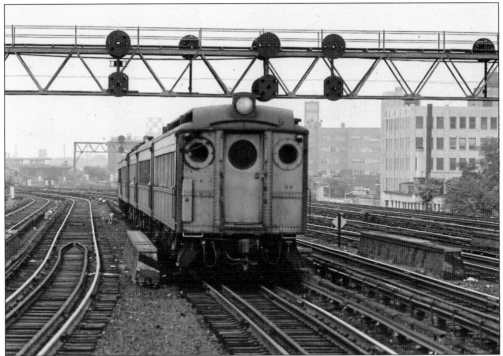

The LIRR ran numerous types of multiple-unit electric cars through the years. Pictured on this page are two different types of MP-54 cars. Above, a car with a clerestory roof (center portion of roof is raised) is seen heading east out of Jamaica Station. Below, an arched-roof car is seen at Queens Village Station. Both photographs were taken in the early 1970s. (Both photographs by Vincent Alvino.)

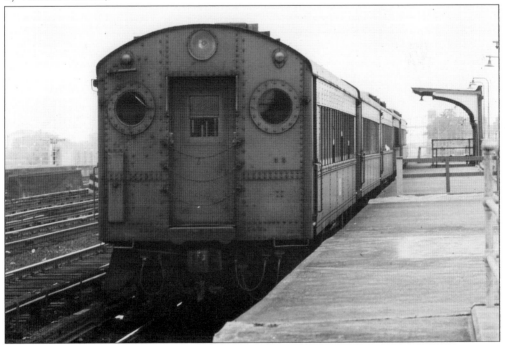

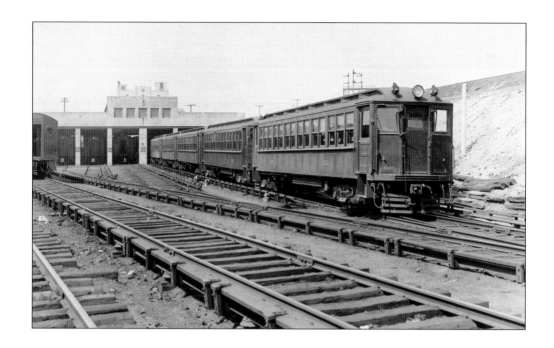

Between Jamaica Station and the Morris Park Shops was a building called Dunton Shop, which was a facility where inspections and light running repairs were made to electric MU cars. The heavy maintenance for these cars was performed in the Morris Park Shops. The first Dunton Shop building was constructed in 1905, in conjunction with LIRR electric service. The building was located at the corner of Van Wyck Boulevard and Atlantic Avenue and had six bays measuring 242 feet in length. The above image shows a May 2, 1930, view of the Dunton Shop with MP-41 cars on an outside track. Below is a view from when the shop was first opened.

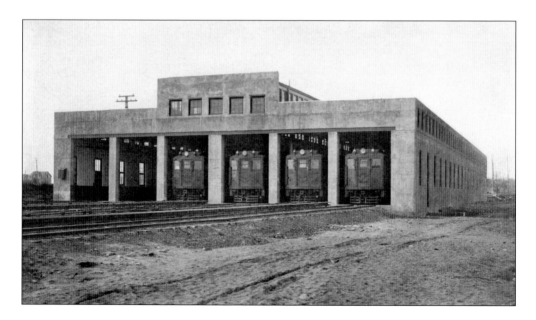

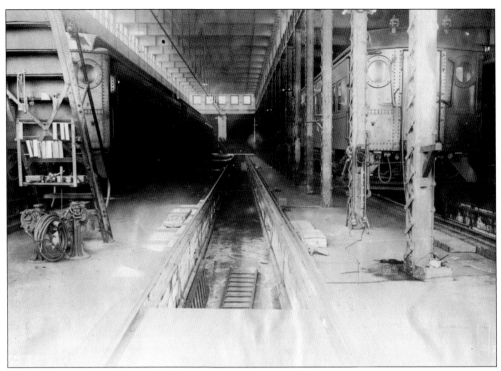

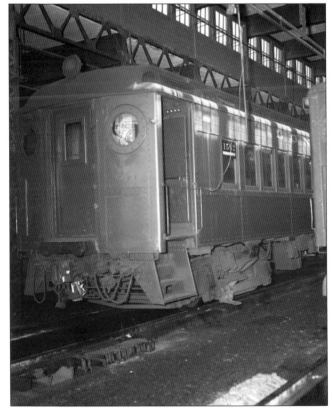

This 1921 valuation photograph shows an interior view of the shop. Each bay had a three-foot-deep pit that allowed shop personnel to inspect underneath the cars. Air-operated jacks can be seen at left.

There was no third-rail power in the shop, so jumper cables were hooked up to allow the cars to be moved. The original Dunton building was demolished in the 1950s, and a newer building was erected. That building was demolished in recent years to make room for construction of the AirTrain Terminal, which opened in 2006. The AirTrain carries people eight miles from Jamaica Station to JFK International Airport. (Photograph by Fred J. Weber.)

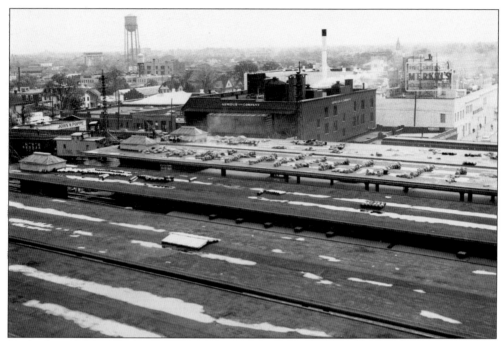

By the late 1800s, Armour and Company was one of the largest meat-processing companies in the country. One of their plants was located on the east side of Sutphin Boulevard in Jamaica, just south of the railroad. By 1900, Armour had over 12,000 refrigerator railroad cars known as reefers. After World War II, trucks started taking over, and by 1960, the fleet was down to less than 2,000 cars. The above photograph (taken around 1960) is significant because it shows one of the reefers on the sidetrack behind the Armour building. This sidetrack would forever become known as "the Armour siding." Below is an enlargement of the above photograph, which clearly shows the reefer at the Armour building loading platform. As an aside, the station platform canopies are being reroofed. (Both courtesy of Arthur Huneke.)

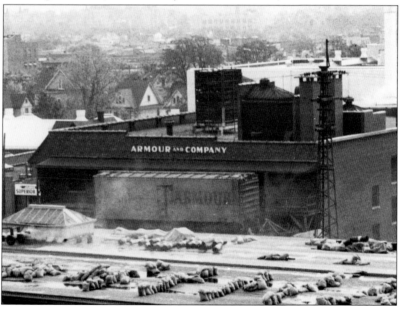

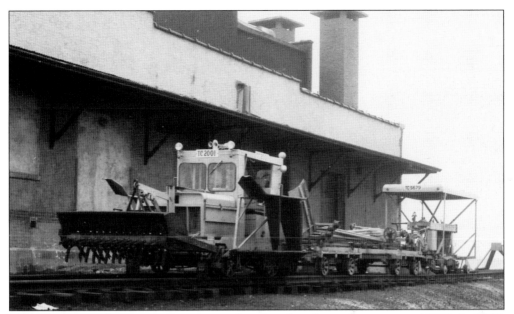

When Armour and Company ceased using the siding for refrigerator cars around 1960, the LIRR maintenance-of-way department took over the siding for the use of track maintenance equipment, as shown in this photograph. (Courtesy of David Keller.)

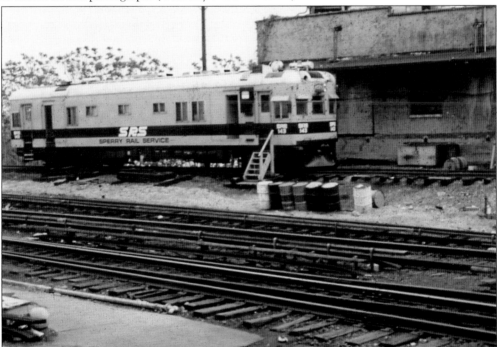

Because the Armour siding was located across the track from Hall Tower, it was considered to be one of the safest locations for storing the Sperry Rail Service cars. These rail-flaw detection cars were on the property several times a year for weeks at a time. The car pictured is BRS143, built in 1974. In a March 2007 rebuild, the Sperry Company named the car *Dick Penwell*. (Courtesy of David Keller.)

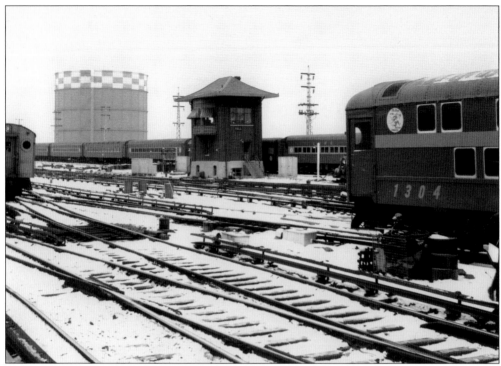

Between 1932 and 1948, the LIRR purchased 63 all-aluminum double-decker cars from Alcoa. These cars increased capacity from 72 (MP-54 cars) to 132 passengers. The last double-decker was retired on March 31, 1972, after being replaced by the M-1 Metropolitan multiple-unit electric cars. Car No. 200, the only surviving double-decker, is in the collection of the Railroad Museum of Long Island in Riverhead. Above, double-decker No. 1304 leads an eastbound train out of Jamaica Station into Hall interlocking. Below, an eastbound train traverses Jay interlocking with a double-decker at the head end. (Above, courtesy of James Mardiguian; below, courtesy of Gene Collora.)

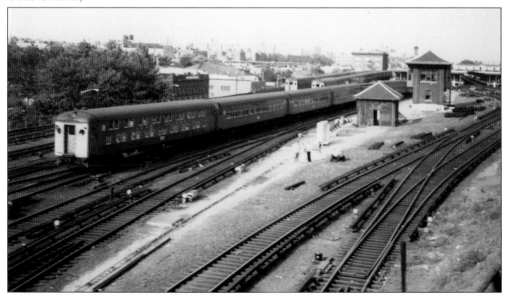

A seemingly simple photograph at first glance, this scene is packed with historical details. Shot from the Union Hall Street Station platform, the equipment in view includes, from left to right, freight cars, an MP-54 passenger car, and a baggage car on the rear end of the westbound passenger train. A trackside cabin and, yes, that gas tank and St. Monica's Church steeple are in view. (Photograph by Vincent Alvino.)

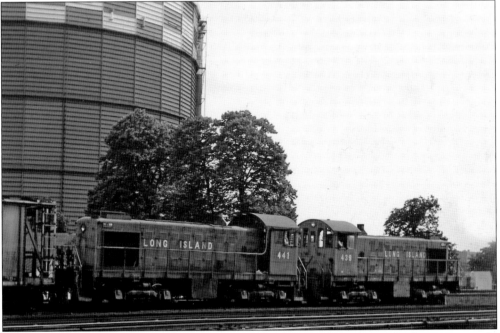

Two S-2 switcher locomotives pull a string of freight cars westbound past the famous gas tank. LIRR freight service is now handled by the New York and Atlantic Railroad over LIRR trackage. (Photograph by Vincent Alvino.)

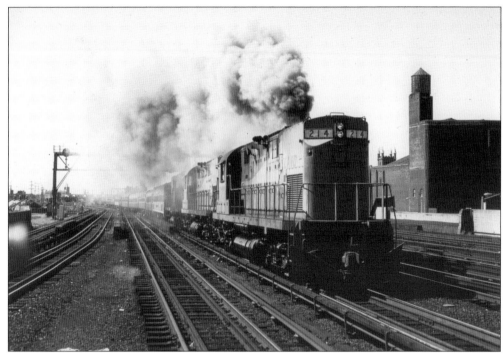

A popular railfan saying states that Alco diesels are "honorary steam locomotives." One look at this September 1969 photograph lends credence to the saying. This Sunday afternoon eastbound Montauk train is passing through Union Hall Street Station, with the former Jamaica Theater on the right. (Photograph by Vincent Alvino.)

Looking across two platforms at Jamaica Station, one can see an Alco 1600-horsepower RS-3 locomotive No. 1560 ready to pull a train eastward. One LIRR RS-3, No. 1556, has been preserved at the Riverhead location of the Railroad Museum of Long Island. (Photograph by Vincent Alvino.)

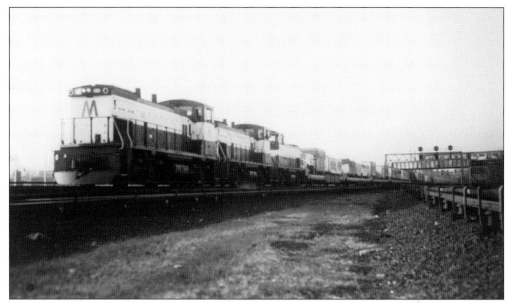

The movement of the circus train through Jamaica Station, en route to Garden City, was always a popular event with employees at headquarters. The Jay Tower train director would notify the train movement bureau that "the circus train is coming!". Word quickly spread through that building, and nearly every nonessential employee would go to platform E and watch the circus train pass by on track No. 8. In this 1970s view, the circus train crosses over the Van Wyck overpass on the way into Jamaica Station. (Courtesy of Gene Collora.)

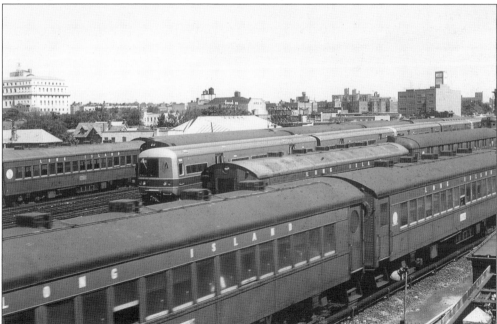

The old and the new can be seen in this August 1969 photograph taken from Hall Tower. A new M-1 train is among the older multiple-unit electric trains. The Queens County Supreme Court building on Sutphin Boulevard, near Jamaica Avenue, can be seen in the left background. (Courtesy of Robert Sturm.)

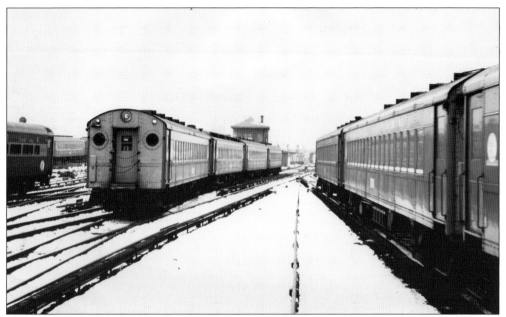

This 1968 photograph shows trains moving through Jay interlocking on a snowy day. On days like this, gas switch heaters were used to keep the interlocking switches from freezing and becoming jammed. (Courtesy of James Mardiguian.)

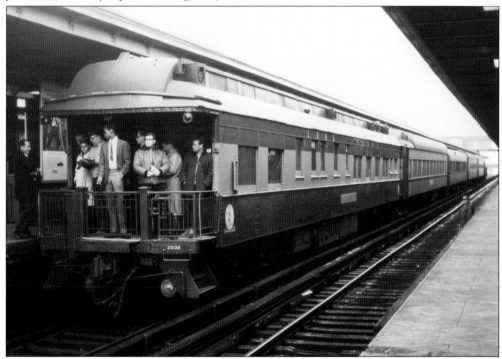

An open-end observation car—*Setauket*, No. 2038—awaits departure at Jamaica Station in this 1970s photograph. It was not uncommon to see this car at the rear end of the *Cannonball*, making a trip to Montauk. Another similar car, No. 2000, *Jamaica*, has been preserved and can be seen at the Wantagh Preservation Society Museum. (Photograph by Vincent Alvino.)

Seven

THE EMPLOYEES WHO MADE JAMAICA WORK

Railroading has always been an extremely labor-intensive industry. It takes an extensive workforce to operate trains safely and efficiently and to provide good customer service. Furthermore, it takes an army of workers to maintain the equipment, tracks, signals, and electric power systems. Of course, there are also the executives, managers, and clerical support staff who back up the operation.

The railroad workforce is spread out over the entire system. Some employees work in ticket offices or on the trains, dealing with the traveling public. Some work in the yards and towers, making up trains and controlling the movement of trains. Some work in the shops, maintaining the locomotives and cars. Others are out on the road maintaining the tracks and signals. There is a legion of support staff working in the headquarters and offices spread throughout the system. All of them operate as a team to keep the railroad running on time.

This chapter takes a look at a few of the people who helped build the 1913 Jamaica Station and some of those who have made the railroad work throughout the years.

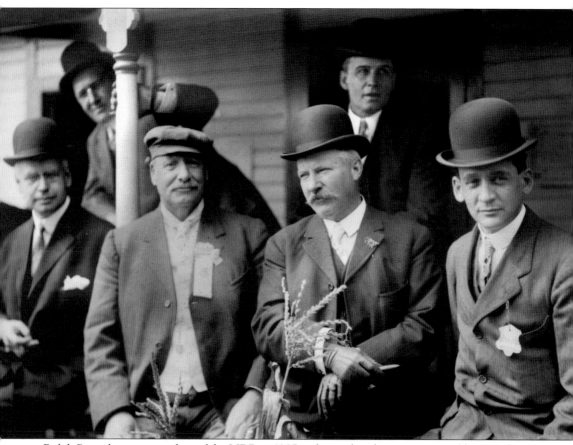

Ralph Peters became president of the LIRR in 1905 and served in that position until his mandatory retirement in 1923 at the age of 70. During his 18-year tenure, he guided the LIRR through a spectacular period of growth. It was during his presidency that the LIRR entered Penn Station, Jamaica Station was elevated, Holban Yard was constructed, and Flatbush Avenue Terminal was opened. In 1910, President Peters commissioned paintings of the 18 presidents who served the LIRR prior to his term. Those portraits hung at the railroad's Penn Station executive offices but were lost over the passing of time. See page 13 for more information about the portrait of the first president, Knowles Taylor. Only two photographs are known to exist of President Peters, both of which are in the collection of the Suffolk County Historical Society in Riverhead, New York. In this photograph, Peters is second from right in the first row. (Courtesy of the Suffolk County Historical Society.)

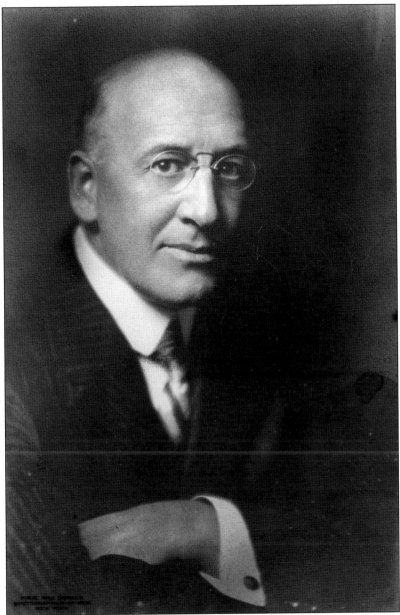

The August 1, 1913, *Railway Age Gazette*, in reporting on the completion of the Jamaica Improvement Project, stated: "The work has all been handled under the direction of John Richard Savage, chief engineer of the LIRR . . . all construction work has been done by company forces under the personal direction of Mr. Savage." Noted railroad historian Vincent Seyfried said, "The work then being done at Jamaica was the most gigantic work in the way of grade-crossing elimination ever carried out by a single railroad in the United States if not the world." Another famous railroad historian, Ron Ziel, said, "The Jamaica project was so successful that years after it went into service, it is considered to be a marvel of foresighted planning. All the more remarkable is the fact that the entire complex was designed and built by the railroad's own engineering department." This photograph of Savage was obtained with the help of retired LIRR transportation manager and genealogist Carol Mills. (Courtesy of Hugh P. Savage.)

The Jamaica Station building was designed by a leading architect of the day, Kenneth M. Murchison. The building is said to be of utilitarian design, with touches of elegance. To gain a full appreciation of the building's architectural beauty, the contiguous structures should be considered as well, for example, the three signal towers, the trainman's welfare facility, and the former Dunton Station building. Murchison designed at least 10 other railroad stations, including the Lackawanna Terminal in Hoboken, New Jersey, and the Lackawanna Station in Scranton, Pennsylvania. He designed two other stations for the Long Island Rail Road, those being Manhattan Beach Station (demolished in the late 1930s) and Long Beach Station (see page 107). One of Murchison's most famous works is the 1923 Forest Hills Tennis Stadium where many great tennis champions have performed. (Courtesy of Hays Browning.)

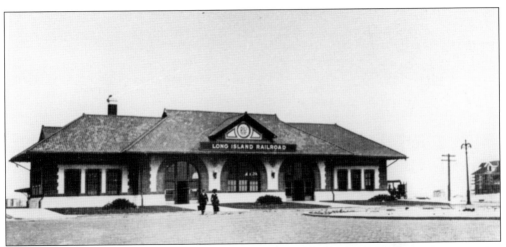

The Long Beach Station building opened in June 1909. Designed by Murchison, the building is brick and stucco, with three large, arched windows in front. The roof is covered with Spanish-style ceramic tiles.

The building looks so much like a train station that could be seen in Florida, Paramount Pictures filmed a Florida movie segment at the Long Beach Station in 1959. In the movie *That Kind of Woman*, starring Sophia Loren and Tab Hunter, the Long Beach Station was supposedly the Miami Station of the Seaboard Air Line Railroad. During a break, Sophia Loren posed with LIRR engineer Frank McKeown on a locomotive at the station. (Courtesy of Long Island Rail Road.)

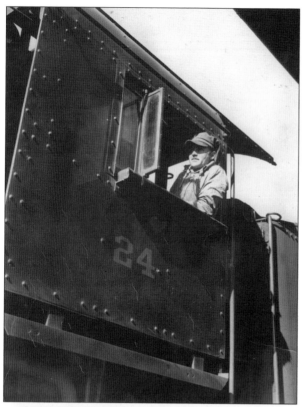

The glamorous job on American railroads is that of engineer. In fact, a US postage stamp honoring the profession was issued on April 29, 1950. On the LIRR, one of the most well known and respected engineers was Cecil A. Craft. Hired in 1918 as a fireman and eventually promoted to engineer in 1925, Craft ran steam and, later, diesel locomotives between Jamaica and Oyster Bay. He dressed in traditional railroad engineer's garb and was known for allowing children to ride on the locomotive. He retired on June 1, 1968, after 50 years of service. At left, Craft sits in the cab of G-5s steam locomotive No. 24. Below, upon his retirement, Craft (left) was congratulated on a Jamaica Station platform by superintendent of engine service Ray Long (center) and LIRR president Frank J. Aikman Jr. (Both courtesy of Oyster Bay Railroad Museum.)

In terms of the popularity of railroad jobs, the position of conductor follows closely behind that of engineer, even though it is the conductor who is in charge of the train. This 1903 view shows two conductors and a baggage wagon piled high with mailbags on the platform at the old Jamaica Station. (Courtesy of Ron Ziel.)

In a publicity shot, the conductor gives the high sign on the Jamaica Station platform as Pres. Thomas M. Goodfellow stands in the train door. Goodfellow served as president from January 1, 1956, to May 28, 1967.

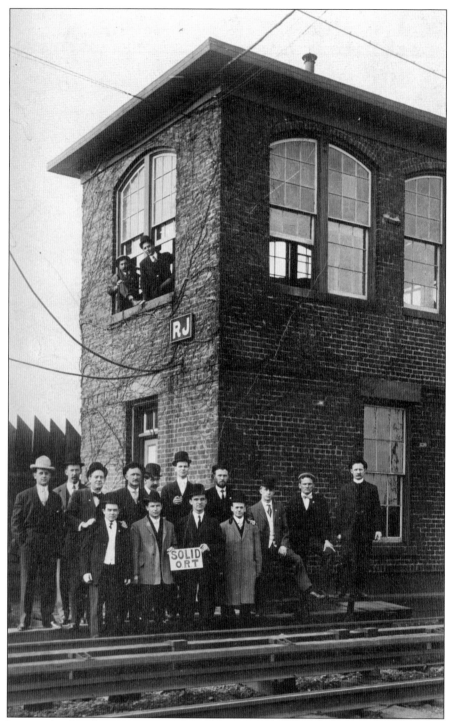

A gathering of railroad union men pose at RJ Tower while holding a sign that says "Solid ORT." ORT was the Order of Railway Telegraphers. RJ Tower was at Rockaway Junction, where the Montauk Branch diverges from the main line. This tower was demolished in 1930 in conjunction with the Jamaica East Improvement Project. (Courtesy of Arthur Huneke.)

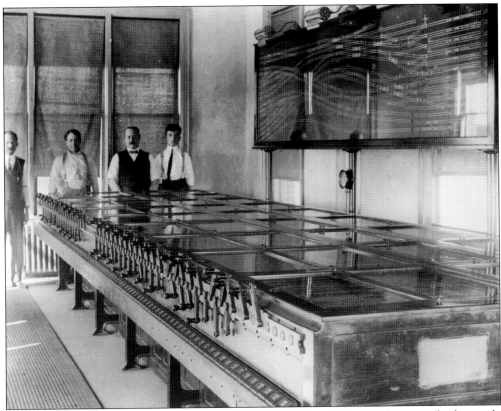

Above, four tower workers pose for a photograph next to the lever machine inside the newly opened Jay Tower in 1913. Below is a scene in the same tower, 75 years later: operator Arthur Huneke is in the left foreground, operator James Raity is in the center background, and an unidentified lever-man is throwing levers that control the interlocking switches. (Above, courtesy of Arthur Huneke.)

The Special Services Department was responsible for the bar-car and parlor-car service during the summer. In this 1970s photograph, director Walter McNamara is on the rear end of car 99, the *Jamaica*, shaking hands with his assistant, Willie Wilson. Wilson was a former Pullman porter and succeeded McNamara as director. The other man is unidentified.

Harry Glueck sits at his desk in Jamaica with new technology—a portable reel-to-reel tape recorder. Glueck rose through the ranks, from crossing watchman, draftsman, and foreman to general road master, finishing his 43-year career as assistant superintendent of track in 1973. He was in charge of the 1955–1956 transfer of the last two G-5s steam locomotives to the counties of Nassau and Suffolk. (Courtesy of Richard Glueck.)

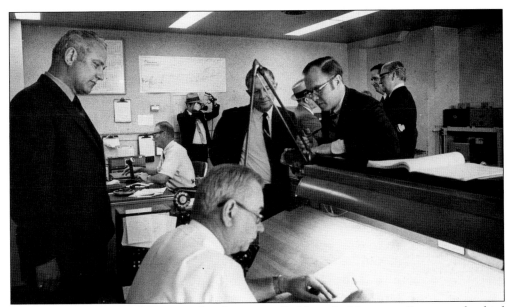

All train movements on the entire railroad are controlled from the Movement Bureau on the third floor of the Jamaica Station building. In this 1970s photograph, transportation superintendent Joseph Valder (left) looks over the shoulder of Section C dispatcher Bill Fauser. The man at the desk in the background is chief train dispatcher Ed Weinberger.

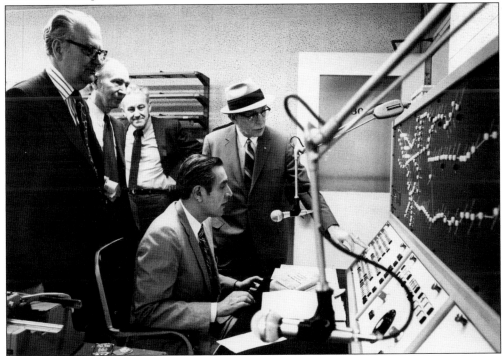

The public address console is located inside the Movement Bureau room. It is here that system-wide announcements may be made, as well as announcements for individual branches or stations. The man wearing the hat is LIRR president Walter L. Schlager Jr., who served from July 28, 1969, until his death in 1976.

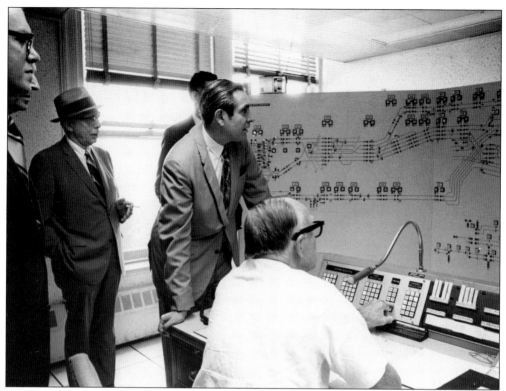

All third-rail power for the railroad is controlled from the power director's office across the hall from the Movement Bureau. Here, with the push of a button, power can instantly be shut off at any point on the railroad. President Schlager is the man wearing a hat and smoking a cigarette.

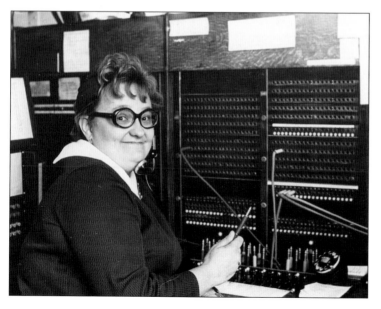

The telephone switchboard operator served a vital function in the headquarters building, although the switchboard appears to be antiquated in this 1970s photograph. The LIRR was rather late in switching over to new telephone technology. Muriel Felter, pictured in this undated photograph, handled the phone jacks, assuring that nobody was cut off.

Anyone who listened to the traffic reports on the radio in the late 1960s and early 1970s should remember the voice of Lou Duro, the public relations department spokesperson seated at right in this image. Those were notorious years for the LIRR, with labor strikes, slowdowns, equipment failures, and an abundance of discontent.

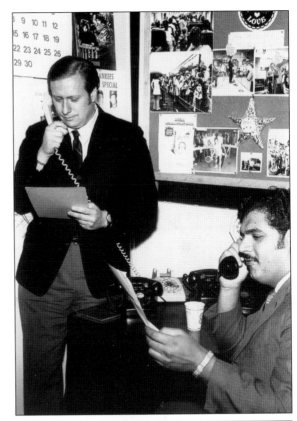

The public relations department has the task of trying to promote a favorable image of the railroad to the public. One function of the department is to spread the word about the good things that the railroad is doing. This young lady is stuffing envelopes with a "Facts and Figures" booklet. Her identity is a mystery, but the year is certain—this booklet was published in 1975, when George O. Thune was in charge of the department and Donald P. Malone was the editor.

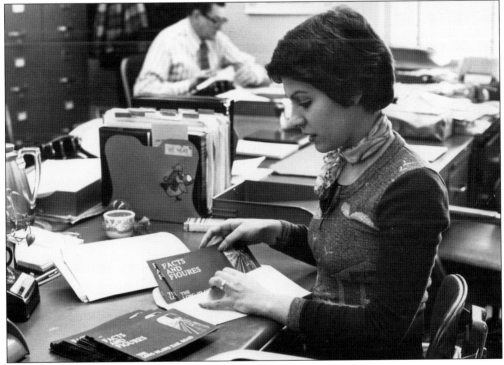

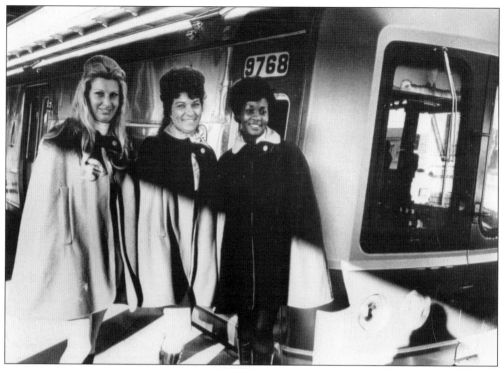

In the 1970s, the public relations department decided to ask the secretaries and clerks in the headquarters building to act as Metro Mini Maids. As such, the ladies went to public areas, such as station platforms and waiting rooms, to distribute literature. A bright-yellow and blue minidress was the uniform of the day. These three women—Jennie O'Connell is in the center and the other two are unidentified—pose next to an M-1 train on a Jamaica Station platform. (Courtesy of Terry Peluso.)

While they were secretaries in the labor relations department, Eileen Gillespie (left) and Claire Persico volunteered to work extra assignments as Metro Mini Maids. Here, they get ready for an assignment at Penn Station. Both women eventually worked in the office of the president. The patches on their hats portrayed a railroad track leading to the sunrise, with a rainbow at the far end of the track. This logo was used on literature and playing cards during the mid-1970s. (Courtesy of Claire Persico.)

This man doesn't seem to mind the Mini Maid pinning a "STEP INTO THE SEVENTIES" button on his lapel. She wears a traditional railroad engineer's cap made from blue-and-white "hickory stripe" material.

An interesting concept that came out of the public relations department in the 1970s was the umbrella bank. This made good use of the hundreds of umbrellas that were turned into the lost-and-found department and never claimed. This woman stands at the information booth (wheelhouse) at the east end of platform E.

In this August 15, 1958, photograph taken at the new postal transfer station, post office department official George Bergman (left) and LIRR president Thomas Goodfellow lift mailbags to promote the new mail-loading platform, commonly referred to by railroad employees as "the mail dock," in Jamaica.

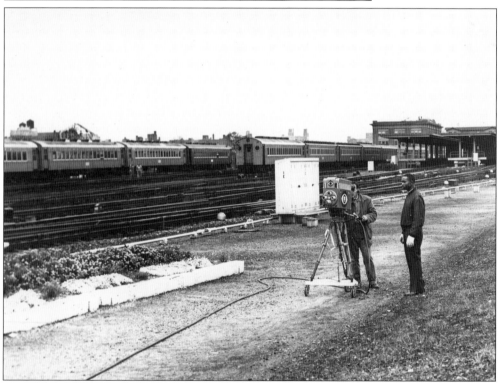

At noon on October 7, 1956, LIRR employees participated in a live CBS-TV broadcast, "Let's Take a Trip," hosted by Irwin "Sonny" Fox. The program gave viewers an opportunity to "look behind the scenes of the nation's busiest passenger railroad." The CBS camera crew is seen here in Jay interlocking with their now-antiquated turret-style lens camera. The Jamaica Station building is in the background at right.

Eight

PRESERVING THE HERITAGE

The Long Island Rail Road has always enjoyed a large following of enthusiasts. There are two chapters of the National Railway Historical Society on Long Island—the Long Island Sunrise Trail Chapter and the Twin Forks Chapter—along with four railroad museums: Railroad Museum of Long Island, Oyster Bay Railroad Museum, Wantagh Preservation Society, and the Lindenhurst Historical Society.

Many communities have been involved in helping to preserve their historic train stations. St. James is a shining example of a community that has cared about its depot through the years.

Numerous persons have written extensively about the railroad's history. Vincent F. Seyfried and Ron Ziel are two such well-known authors. Photographers and artists, too numerous to mention, have also helped preserve the railroad's history.

Many local libraries have specialized collections of LIRR photographs, maps, and documents in their archives, including the public libraries in the boroughs of Brooklyn and Queens, the college libraries at Hofstra University and Stony Brook University, and the Suffolk County Historical Society Library.

This chapter deals with some aspects of the preservation of LIRR history pertaining to Jamaica Station.

Syosset resident Lou Mallard has been painting local railroad scenes for over 35 years. His work was a well-kept secret among the Long Island railfan community until a few years ago, when he started displaying his paintings at local libraries and at the Oyster Bay Railroad Museum. Above, steam locomotive No. 28 hauls a freight train through the Jamaica area while a child looks out the window of a passenger train. Below, steam locomotive No. 31 passes Dunton Tower as the pigeons observe from overhead wires. (Both paintings by Lou Mallard.)

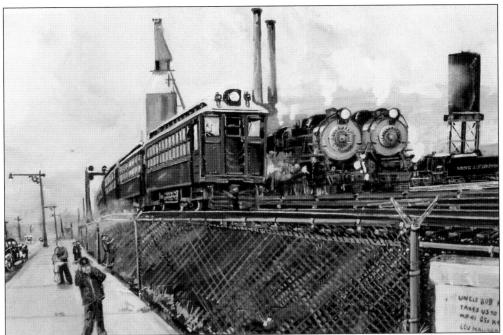

Lou Mallard drew inspiration from published photographs, as well as recollections of his own experiences. Above, Mallard remembered walking along Atlantic Avenue as a boy and looking at the locomotives at the Morris Park Shops facility and the passing trains on the Atlantic Branch. Below, Mallard painted the DD-1 electric locomotive No. 360 at Dunton Tower based on a Fred Lightfoot 1947 photograph that appeared in Ron Ziel's book, *Electric Heritage of the Long Island Rail Road.* (Both paintings by Lou Mallard.)

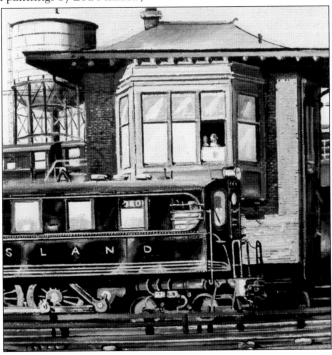

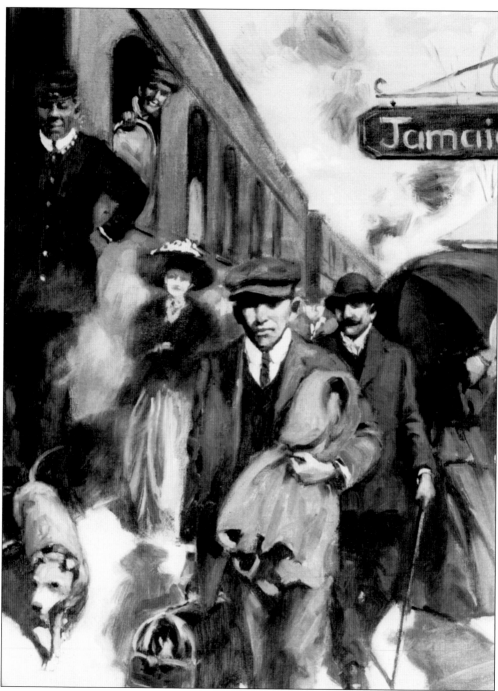

In the early 1900s, a dog named Roxey became the official LIRR mascot. Roxey's story is told in *Miles of Smiles: The Story of Roxey, the Long Island Rail Road Dog*, a recently published children's book written by Heather Worthington and illustrated by Bill Farnsworth. Roxey was known for riding trains throughout the system, and, as Heather notes in her book, "he changed trains at Jamaica." Bill painted this image of Roxey on the Jamaica Station platform, showing the train conductor's apparent amusement at the dog's antics. (Courtesy of Bill Farnsworth.)

Jerry Strangarity of Cincinnati, Ohio, is a leader in the field of scratch-building models. The December 1993 issue of *Railroad Model Craftsman* contained a five-page feature article that Jerry wrote about his scratch building of Jamaica Station. This complex model was finely detailed by Jerry and is now owned by Mike Hill, a retired hobby shop owner from Buffalo Grove, Illinois. Above, Jerry's model shows the intricate fire escape on the west end of the building. Below, his model shows the detail of the Sutphin Boulevard entrance, with the chains and brackets supporting the marquee and the keystones in the centers of the top window frames. (Both courtesy of Jerry Strangarity.)

To a Long Island Rail Road commuter, the phrase "change at Jamaica" is all too common. In 1957, Warren Goodrich, an LIRR commuter, wrote an illustrated hardcover book titled *Change at Jamaica*. The book, a satire about riding on the LIRR, forces the reader to make a change—after reading halfway through the book, the reader is required to turn the book upside-down to read the other half. This book might not have made the *New York Times* best-selling list, but no LIRR library is complete without a copy.

In 1987, the Long Island Rail Road Historical Society was formed to assist the LIRR in celebrating the 75th anniversary of the Jamaica Station building. A ceremony was held in the building lobby at noon on March 9, 1988. John Hehman created a drawing of the building, which was the centerpiece in an anniversary logo produced by the LIRR. This drawing appeared on the March 14, 1988, city terminal zone timetable, as well as on medallions produced by the LIRR. (Courtesy of Long Island Rail Road.)

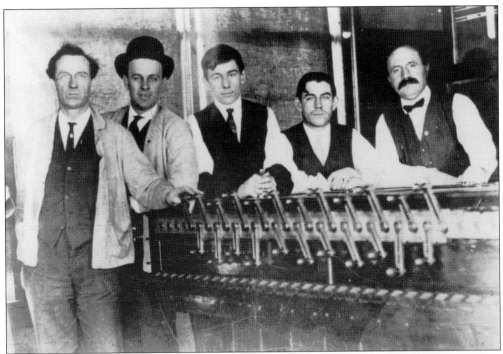

The star of the show at the 75th anniversary ceremony was Richard "Old Man" Kelly, a retired train director who worked at Hall Tower for nearly 50 years until his retirement in 1962. The LIRR became aware of Old Man Kelly's availability through the above 1913 photograph, in which Kelly is the young man in the center of the group. At right is a photograph of Old Man Kelly taken inside Hall Tower when he visited it in 1988. At the end of his visit, upon leaving the tower, he turned and said to the tower employees, "Don't worry boys, I won't bump you." (Above, courtesy of Arthur Huneke.)

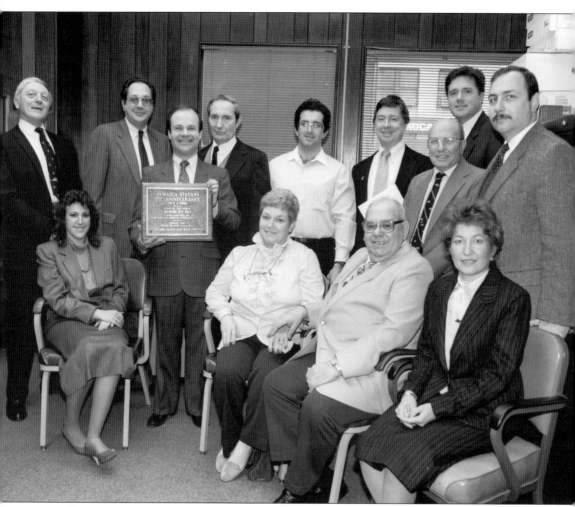

At the end of the March 9, 1988, ceremony, members of the Long Island Rail Road Historical Society posed for a group photograph. They are, from left to right, (first row) Michele Tifverman, Neusa Zambuto, Rozie Zambuto, and Ana Gago; (second row) Vincent Seyfried, Gene Collora, John Hehman, Robert Presbrey, Carl Dimino, Richard Krehl, James Boerckel, David Morrison, and Thomas Tomaskovic. Hehman proudly holds the commemorative plaque indicating that Jamaica Station was open to the public on March 9, 1913, upon the arrival of the 4:47 a.m. Speonk newspaper train.

Carl Ballenas ended his book *Jamaica* by referring to the citizens of Jamaica as being "the caretakers of Jamaica." It is the employees of the Long Island Rail Road who are the caretakers of Jamaica Station.

BIBLIOGRAPHY

Ballenas, Carl. *Jamaica*. Charleston, SC: Arcadia Publishing, 2011.

———. *Jamaica Estates*. Charleston, SC: Arcadia Publishing, 2010.

Goodrich, Warren. *Change at Jamaica—A Commuter's Guide to Survival*. New York: Vanguard Press, 1957.

Hendrick, Daniel M. *Jamaica Bay*. Charleston, SC: Arcadia Publishing, 2006.

Keller, David, and Steven Lynch. *The Long Island Rail Road 1925–1975*. Charleston, SC: Arcadia Publishing, 2004.

———. *Revisiting the Long Island Rail Road 1925–1975*. Charleston, SC: Arcadia Publishing, 2005.

Morrison, David D., and Valerie Pakaluk. *Long Island Rail Road Stations*. Charleston, SC: Arcadia Publishing, 2003.

Myers, Steven L. *Lost Trolleys of Queens and Long Island*. Charleston, SC: Arcadia Publishing, 2006.

Potter, Janet Greenstein. *Great American Railroad Stations*. New York: John Wiley & Sons, Inc., 1996.

Worthington, Heather Hill. *Miles of Smiles: The Story of Roxey, the Long Island Rail Road Dog*. West Bay Shore, NY: Blue Marlin Publications, 2010.

The books of Vincent F. Seyfried and Ron Ziel are important sources of information, however, the list of their books is too numerous to cite. For further reading, see "Long Island Improvements at Jamaica" in *Railway Age Gazette*, August 1, 1913; "Grade Crossing Elimination on the Long Island" in *Railway Age*, May 2, 1931; and *Long Island Railroader* employee magazines.

www.arcadiapublishing.com

Discover books about the town where you grew up, the cities where your friends and families live, the town where your parents met, or even that retirement spot you've been dreaming about. Our Web site provides history lovers with exclusive deals, advanced notification about new titles, e-mail alerts of author events, and much more.

MADE IN THE

Arcadia Publishing, the leading local history publisher in the United States, is committed to making history accessible and meaningful through publishing books that celebrate and preserve the heritage of America's people and places. Consistent with our mission to preserve history on a local level, this book was printed in South Carolina on American-made paper and manufactured entirely in the United States.

This book carries the accredited Forest Stewardship Council (FSC) label and is printed on 100 percent FSC-certified paper. Products carrying the FSC label are independently certified to assure consumers that they come from forests that are managed to meet the social, economic, and ecological needs of present and future generations.

FSC
Mixed Sources
Product group from well-managed fores*s and other controlled sources

Cert no. SW-COC-001530
www.fsc.org
© 1996 Forest Stewardship Council

Find Your Place in History.